# Recreational Folk Dance

## Second Edition

**Susanne J. Davis**
**Colleen N. West**
**Brigham Young University**

Cover images courtesy of the authors.

**Kendall Hunt**
publishing company

www.kendallhunt.com
*Send all inquiries to:*
4050 Westmark Drive
Dubuque, IA 52004-1840

ISBN 978-0-7575-5768-2

Printed in the United States of America
10 9 8 7 6 5 4

# Contents

# Introduction

One of the oldest and most widespread art forms, folk dancing, transcends the barriers of creed and race. This art form provides all nations with a common language. Chester Kuc, founder and organizer of the Canadian "Cheremosh Ukrainian Dance Ensemble" writes,

Folk Dancing is a commentary on a people's character, temperament, feelings, and attitudes toward life. It is also a reflection of their spiritual and material culture brought back to life on stage.

Traditionally, folk dancing has been used to portray the culture of a people and to serve vividly as a social, ritual, or recreational outlet. Staging folk dances as a choreographic theatrical art is gaining rapid popularity among dancers and audiences alike. Choreographers have researched various movement patterns from villages, and then have choreographed dances that display on stage the attitude of people's lives, traditions, values, and customs. This in turn educates an audience, helps preserve culture, and establishes folk dance as an art form.

Theatrical folk dances have lost some of their authenticity because of varying interpretations of choreographers, participants, audiences, music, and functions; but they have sustained some reflections of the culture through the symbolism and traditions portrayed in the styling and basic steps of the dance.

The origin and development of folk dance can be traced to prehistoric times. Dance was a manifestation of man's emotional and spiritual being. It was also an imitated expression of various elements of nature: ritual dances were the communication between man and the powers of nature.

Through the years, the survival of these dances (combined with the Christian rituals and the church calendar) became an important part in the festivities of the peasant. The ritual dance depicted various aspects of the people's lives. Dance originated from 1) the character of the work performed in everyday life, 2) the mannerisms and customs of the people, 3) the natural environment, 4) the consistent search for social freedom and national independence, and 5) the ritual and religious base of society.

Events of the life cycle, such as birth, adolescence, marriage, and death, were depicted through the combination of rhythm and movement. Early dances also fulfilled a recreational need. They developed spontaneity and improvisation, with improvisation staying within the framework of traditional steps. These early dances were performed in the village environment.

In most cultures, the early forms of dance often combined movement with song. Only in later times did the separation of song, dance, and music begin. Folk dance transcends country borders which generates an assortment of dance styles, costumes, and musical accompaniment. These styles are modified by climate, religious beliefs, topography of land, social, economic, and cultural influences of neighboring countries.

Folk dance reflects a people's soul, temperament, culture, and tradition. It allows one to learn and appreciate the contrasts and similarities we share throughout the world.

# Map of Europe

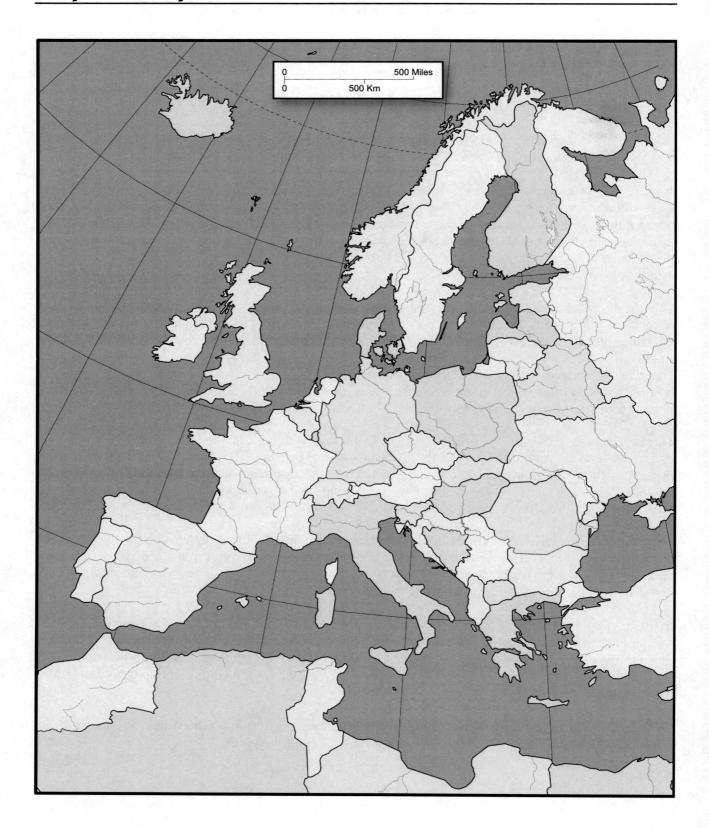

# Map of Eastern Europe

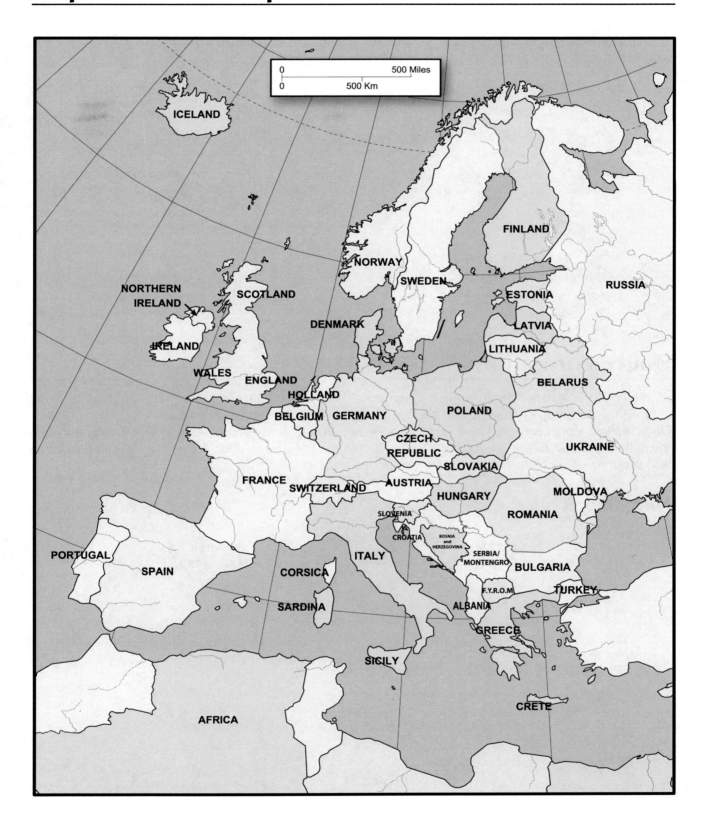

# List of Dance Abbreviations

An explanation of abbreviations clarifies the reading of the dance briefs. These abbreviations are used to save time and space in the writing process. After you have learned the abbreviations, it will become second nature to translate them.

| | | | |
|---|---|---|---|
| BK | back | M | men |
| FWD | forward | W | women |
| CCW | counter clockwise | R | right |
| CW | clockwise | L | left |
| LOD | line of dance | DIAG | diagonal(ly) |
| RLOD | reverse line of dance | q | quick |
| Ptr(s) | partner(s) | S | slow |
| FT | foot | Pt | point |
| XIF | cross in front | Ct(s) | count(s) |
| XIB | cross in back | Meas | measure |
| HL(s) | heel(s) | Ftwk | footwork |

# Dance Formations

In folk or ethnic dances, the formation determines the way the dance is performed. A *formation* is the *design* that the *group* creates on the floor. In many dances, the formation changes a number of times. Other dances may keep the same formation throughout. In some dances part of the group is in one formation and part of the group is in another formation, but they may be doing the same step patterns and sequence. Following is a list of the formations used in this text.

## Formation Key

**Men**
**(Arrow)**

**Women**
**(Triangle)**

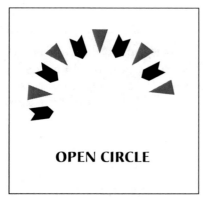

**OPEN CIRCLE**

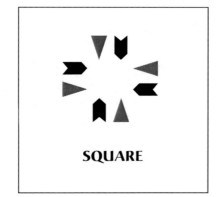

**SQUARE**

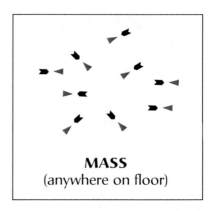

**MASS**
(anywhere on floor)

**LINE**
(can also be all M or W)

**LONGWAYS SETS**

**SET OF THREE FACING**

**2 COUPLES FACING**

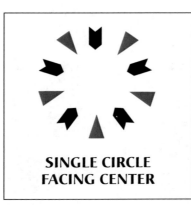

**SINGLE CIRCLE
FACING CENTER**

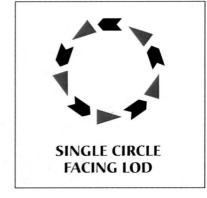

**SINGLE CIRCLE
FACING LOD**

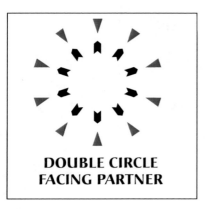

**DOUBLE CIRCLE
FACING PARTNER**

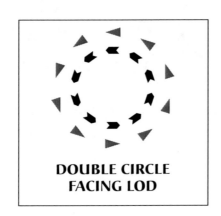

**DOUBLE CIRCLE
FACING LOD**

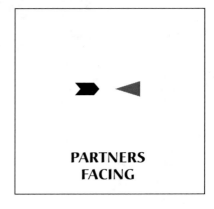

**PARTNERS
FACING**

# Dance Positions

Folk dancing has many different positions with emphasis on the hands, arms, and body carriage. A *position* is how dancers *stand* in relationship to their *partners* and *others* around them. Many dance positions add variety to dances and are very cultural specific. Often, a position in a certain dance may be different for the men or women and can also change through the dance. Following are pictures showing examples of positions used in the dances in this text.

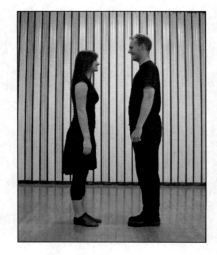

**NO CONTACT**

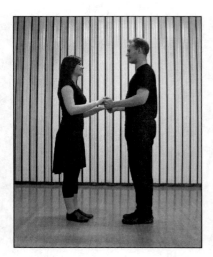

**TWO-HANDS
HELD AT WAIST**

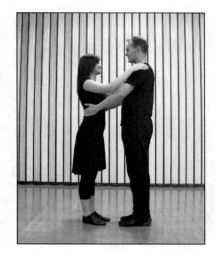

**SHOULDER
WAIST**

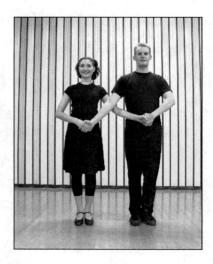

**PROMENADE**

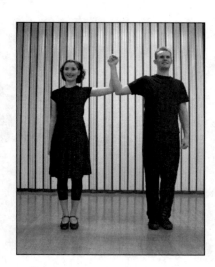

**PROMENADE
(Variation)**

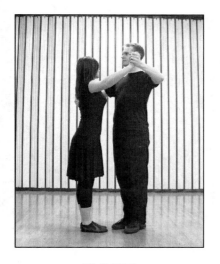

**CLOSED**

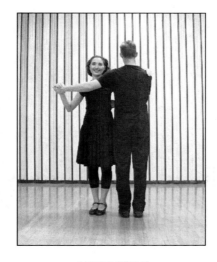

**LEFT SIDE**

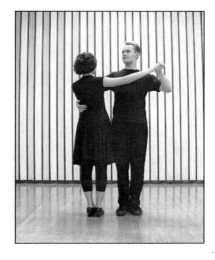

**RIGHT SIDE**

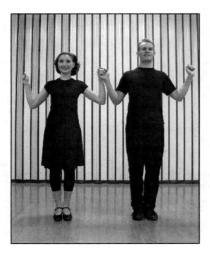

**HANDS HELD IN "W"**

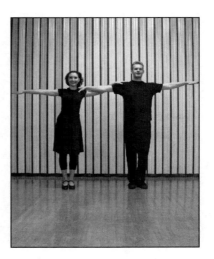

**T-HOLD**

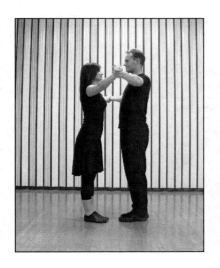

**PARALLEL**

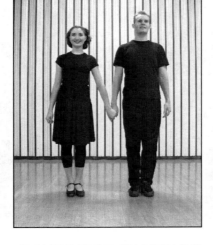

**HANDS HELD IN LOW "V"**

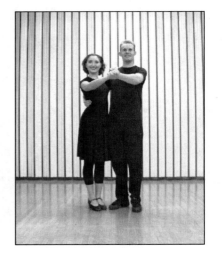

**SEMI-OPEN**

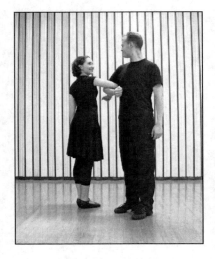

**RIGHT ELBOW**

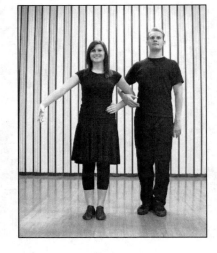

**TEACUP**

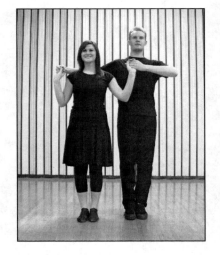

**VARSOUVIENE**

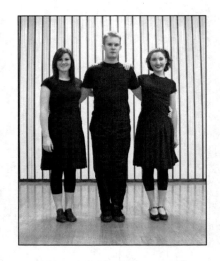

**THREESOME FRONT VIEW**

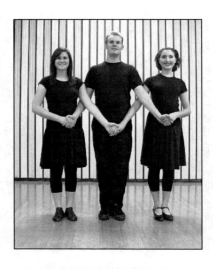

**FRONT BASKET LEFT
OVER RIGHT**

**BACK SKATERS
(Back)**

**BACK SKATERS
(Front)**

# Dances Listed by Country

The following lists the countries and the dances found in this text. We hope that the list invites the dancer to have an experience with numerous international dances, many of which are recognized by folk dancers the world over.

ARMENIA
Armenian Miserlou

BULGARIA
Bučimiš

CANADA (Quebec)
La Bastringue

CZECH REPUBLIC
Doudlebska Polka

ENGLAND
Arnold's Circle
Cumberland Square

GREECE
Syrtos

GERMANY
D'Hammerschmiedsg'selln
Sauerlaender Quadrille

HUNGARY
Czardas Vengerka
Somogyi Karikázó

IRELAND
Sweets of May

ISRAEL
Debka Shachar
Yibanei Hamigkdash
Uvneh Yerushalayim
Stav Lavan

JAPAN
Tokyo Dontaku

LITHUANIA
Ziogelis

MACEDONIA
Da Mi Dojdeš
Jovano Jovanke

MEXICO
Corrido
La Raspa

NORWAY
Komletrø

ROMANIA
Hora de Mâna
Rustemul

RUSSIA
Korobushka

SCOTLAND
Canadian Barn Dance
Road to the Isles
Trip to Bavaria
Oslo Waltz (Scottish/English)

SERBIA
Čapkan Dimčo
Kolubarski Vez
Orijent

SWEDEN
Mona's Festvals

UKRAINE
Kosa
Metelytsia

USA
Cotton-Eyed Joe
Salty Dog Rag
Jacob Hall's Jig

# Dances Listed by Skill Level

The dances in this text are divided into three levels: beginner, intermediate, and advanced. There will be some overlap as to difficulty depending on the dancer's ability. What may be more difficult for one, may be less so for another. An attempt will be made to place them in the most accurate level of skill for the beginner.

## Skill Level I

| | |
|---|---|
| Armenia | Armenian Miserlou |
| Czech Republic | Doudlebska Polka |
| England | Cumberland Square |
| Greece | Syrtos |
| Germany | D'Hammerschmiedsg'selln |
| Israel | Yibanei Hamigkdash |
| Japan | Tokyo Dontaku |
| Macedonia | Jovano Jovanke |
| Norway | Komletrø |
| Scotland | Canadian Barn Dance and Road to the Isles |
| Serbia | Čapkan Dimčo |
| Mexico | La Raspa |

## Skill Level II

| | |
|---|---|
| Bulgaria | Bučimiš |
| Canada | La Bastringue |
| England | Arnold's Circle |
| Hungary | Czardas Vengerka |
| Israel | Debka Shachar, Uvneh Yerushalayim, and Stav Lavan |
| Lithuania | Ziogelis |
| Macedonia | Da Mi Dojdeš |
| Romania | Hora de Mâna and Rustemul |
| Russia | Korobushka |
| Scotland | Oslo Waltz |
| Serbia | Kolubarski Vez and Orijent |
| Sweden | Hambo and Mona's Festvals |
| Ukraine | Kosa, Metelytsia |
| U.S.A. | Cotton-Eyed Joe, Salty Dog Rag, and Jacob Hall's Jig |

## Skill Level III

| | |
|---|---|
| Germany | Sauerlander Quadrille |
| Hungary | Somogyi Karikázó |
| Ireland | Sweets of May |
| Scotland | Trip to Bavaria |
| Mexico | Corrido |

# Definitions of Dance Steps

The understood basic movements of dance are walk, run, leap, hop, jump, and skip. There are many combinations of these steps that result in specific step patterns. The following are the most commonly used steps in the dances within this text.

**Balancé:** Step FWD on R FT, change weight from L to R (ball change). The step is usually repeated on the opposite FT going BK. (Counted 1 & 2)

**Bihunets:** Leap FWD on R FT, small run FWD on L FT, small run FWD with R FT. Repeat on L FT. (Counted 1 & 2)

**Bokazo:** Cross R FT in front of L FT and jump on both feet at the same time (Ct 1), jump on both feet with both toes turned toward each other (pigeon-toed) (Ct 2), bring feet together sharply, both feet FWD. (Ct 3), hold (Ct 4). *Also called *Hungarian Break Step.*

**Brush:** With the weight on L FT, brush the floor with the ball of the R FT FWD or BK. Repeat on R FT.

**Buzz-turn:** Step to L side with ball of L FT, (ct &) step R XIF L, (ct 1). Repeat this step while in closed position with PTR. *This step should turn CW while rotating around a fixed point on the floor between the partners.

**Cifra:** Standing on L FT, take a small leap FWD onto R FT, step L next to R FT, step R in place. Leap DIAG BK with L FT, step R FT next to L, then step L in place. The step progresses to L. (Counted 1 & 2) *This step may also go from side to side.

**Čukče:** Lift onto the ball of the foot of the standing leg, with the other foot poised across in front either slightly off the floor for women, or with the knee bent and the leg lifted quite high for the man.

**Czardas:** Step R to R, close L FT to R, step R to R, touch L FT to R; step L FT to L and touch R FT to L. Repeat step progressing to R.

**Dot:** Step to L on L FT, bring R FT XIB L FT and touch top of toe to floor. Repeat to R.

**Draw-step:** Step L FT to L, bring R FT to the instep of the L FT in a sliding or drawing action and step on it. Step is often repeated in same direction.

**Grapevine:** Step on the R FT to the R side, step on L FT XIB of R FT, step on the R FT to the R side again, and step on L FT XIF of R FT. The step is often repeated. *The grapevine may be done either direction and the crossing of the FT may be either in front or BK to begin the step.

**Grasshopper:** Start on R FT, go FWD with 2 two-steps and end on second two-step by bending L knee in a slight FWD dip. Starting with R FT, do 2 two-steps BK ending with a BK dip. *When doing the dip, lean your body slightly FWD or BK.

**Heel-toe Polka:** Hop on the R FT, extend the L HL to the L side; Hop on the R FT and place the L toe by the R HL, do one polka step to the L. Repeat step on the L FT.

**Holubchuk:** Turn with R or L sides together with a partner, do "Bihunets" step to rotate around each other. If R sides are together, the R arms will be around each other's waist and the free arm will be extended straight in the air.

**Hop:** Standing on R FT, spring off the R FT and land again on the R FT. There is no transfer of weight to the L FT.

**Leap:** Transfer weight from the R FT to the L FT by pushing off with a slight spring and landing on L FT. Both feet are momentarily off the floor at the same time.

**Lepo:** Step R FWD and XIF of L FT, Step L DIAG BK to L. Repeat step progressing L.

**Pas de Basque:** With weight on L FT, leap DIAG R on R FT (Ct 1), step on the ball of L FT momentarily in front of R toe (Ct &). Step in place with R FT (Ct 2), and repeat starting with weight on the R FT. (rhythm is qqS)

**Polka:** Hop on L FT, step FWD on R FT, step L FT beside of R FT, then step FWD R FT. Repeat starting with the R FT. *This is a description of a polka that travels FWD without a partner.

**Prytup:** Standing on L FT, leap to R on R FT, step L FT beside R FT, place weight back on R FT. (Counted 1 & 2, 3 & 4)

**Push-step:** Place weight on L toe beside R FT, step sidewards to R with a R FT pushing with the ball of the L FT (bending R knee slightly and leaning to R). Repeat the pushing action. (Counted & 1 & 2)

**Reel:** Standing on L FT, hop on L FT, step on R FT XIB of L FT, hop on R FT, step on L FT XIB of R FT. Repeat Steps. (Counted & 1, & 2)

**Rida:** Step to R side on ball of R FT, XIF with a flat L FT bending the knee slightly, repeat the step as it progresses to the R. (Count & 1, & 2) This description is a stylized up-rida.

**Set-step:** Take a small leap to R on R FT, in turn-out position, step L FT to instep of R FT momentarily, step BK onto R FT. Repeat to L side. (Counted 1 & 2, 3 & 4)

**Sevens and threes:**
>   **The seven step:** Standing on the L FT, swing R in BK of L and step on the ball of the R FT (Ct 1), step L to L side (Ct 2), step R XIB of L (Ct 3), step L to L side (Ct 4), step R XIB L FT (Ct 1), step L to L side (Ct 2), step R XIB of L (Ct 3), hop on R FT (Ct 4).
>
>   **The three step:** Step L XIB of R (Ct 1), step R in place (Ct 2), step L in place (Ct 3), hop on L FT (Ct 4). Step R XIB L (Ct 1), step L in place (Ct 2), step R in place (Ct 3). *This completes one seven's and three's moving to the L. To move R, reverse the above step pattern.

**Schottische:** Step with R FT FWD, step L FT FWD, step R FT FWD, hop on R FT. Repeat on L FT. (Counted 1, 2, 3, 4, or 1 & 2 &)

**Scissors:** Standing on L FT with knee slightly bent, place R FT straight FWD flat on floor, shift weight by sliding R FT BK and slide L FT FWD. *Feet are in contact with floor at all times.

**Skip-change-of-step:** Hop on L FT (Ct &), Step FWD R FT (Ct 1), close L to R Heel (Ct &), step FWD R (Ct 2), Hop on R FT (Ct &4). Repeat and Reverse.

**Soldado:** The M begins with his back to the center of a circle and takes 4 bouncing, walking steps straight BK starting on the R FT. Moving diagonally L out of the center take four, bouncing, walking steps FWD starting on the R FT. Repeat action to represent a zigzag pattern. This step is done with a partner.

**Step-close:** Standing on the L FT, take a small step to the R side on Ct 1, bring the L FT to the R and step on Ct 2. Repeat the step as indicated.

**Strathspey:** Step FWD R FT, close L to R, step FWD R FT, lift R HL slightly as L FT swings through and reaches FWD for next step. *Feet are turned out at all times for style.

**Touch:** Step in place with the L FT, lightly tap the toe (with no weight) of R FT next to L FT. Repeat and reverse.

**Two-step:** Step R FT FWD, bring the L FT to the R, step R FT FWD and hold. Repeat, starting with the L FT. (Counted 1 & 2)

**Waltz:** Step FWD L, sideward R FT, close L to R (taking the weight on the L FT). Step BK R, sideward L FT, close R to L FT (taking the weight on the R FT.) *This is a completed box step. The waltz may also be done progressing FWD.

**Yemenite:** With weight on L FT, step shoulder width with R FT to R side and lean slightly R, step BK on L FT, step with R FT XIF of L FT. Repeat and reverse. (Counted 1 & 2)

# Styling

Style cannot be overlooked in an ethnic focus on dance, for style is the characteristic that sets each dance apart; it is the feeling and movements that make it unique and distinctive.

Each country has its own "style," and furthermore, each area of the country has its distinct characteristics. Many different factors influence the styling of a country's dance—history, religion, climate, music, topography, costuming or clothing, and the temperament of the people.

One would need to study the specific area of the country the dance comes from to determine the exact style for that dance.

# Dance Descriptions

# Armenia  Armenian Miserlou

"Armenian Miserlou" is also known by the title of the music "Sirdes." It is one of the most popular dances at Armenian parties.

| | |
|---|---|
| **Pronunciation:** | MIH-sehr-loo |
| **Formation:** | Lines |
| **Position:** | Hands held at shoulder height in "W," linking little fingers |
| **Meter:** | 4/4 |
| **Sequence:** | A. Touches |
| | B. Two cross steps and grapevines |
| **Basic Steps:** | Touches and grapevines |

## Dance Description

*Meas*

None    Introduction

### Part I

1    Facing center, touch L in front of R (Cts 1-2)

Touch L out to L side (Cts 3-4)

2    Repeat Cts 1-4 (Cts 5-8)

### Part II

1    Step L (XIF) (Cts 1-2) travel FWD Step R (XIF) (Cts 3-4) travel FWD

2    Step L (XIF), step R to R, step L (XIB), step R to R (Cts 5-8) (grapevine)

**Repeat the entire dance from the beginning**

### Additional Information

During the touches, the knees and the arms remain flexible and pulse subtly with the music.

# England  Arnold's Circle

This dance was choreographed by the late Pat Shaw in honor of his friend, Arnold Bokel, of Hamburg, Germany. It was presented in 1980 by Steve Kotansky at the University of the Pacific Folk Dance Camp.

| | | |
|---|---|---|
| **Formation:** | Double Circle, M backs to the center, Ptrs facing each other |  |
| **Position:** | No contact, arms held down by side | |
| **Meter:** | 4/4 | |
| **Sequence:** | A. R hand pass, L hand pass, balancé, W turns under B. Weave and swing | |
| **Basic Step:** | Walk | |

## Dance Description

*Meas*

1        Introduction

### Part I

1-2      With R hands joined, walk 4 steps to change places with Ptr, R, L, R, L (pass R shoulders) (Cts 104)

3-4      Join L hands, walk 4 steps to change places with Ptr, R, L, R, L (pass L shoulder, do not release L hands. To complete single circle, walk FWD an extra 1/4 turn and join hands with person on R) (Cts 5-8)

5-6      Balancé (FWD) R, balancé (BK) L (Cts 9-12)

7-8      (Release L hands with Ptr and keep R hands joined with new Ptr) To change places with new Ptr: M walk R, L, R, L (FWD), raising R hand. W turn under (CCW), moving feet R, L, R, L. W end with BK to center (Cts 13-16)

9-16     Repeat Cts 1-16 (end with original Ptr) (Cts 16-32)

### Part II

1-4      W stand in place. Men go 1st. Taking 8 walking steps, M pass R shoulders of Ptr, circle behind her, pass between Ptr and next W, pass the next W in front, and end facing the third W. (M move CW) (Cts 1-8)

| | |
|---|---|
| 5–8 | Swing (buzz turn) in closed position with third W (Cts 9–16) |
| 9–16 | Repeat Cts 1–16 (M stands in place, W travels), *always* traveling to the R. (W move CCW) (Cts 16–32) |

**Repeat the entire dance from the beginning with new Ptr**

### Additional Information

When teaching this dance, an easy cue for the weave is "Go around the first, in front of the next, now onto the third and swing."

---

# Bulgaria ◆ Bučimiš

"Bučimiš" is a well known line dance using the typical front basket hold. This dance is from the Shope region in western Bulgaria. Intricate footwork and various movement patterns are common in this region.

| | |
|---|---|
| **Pronunciation:** | boo-chee-MEESH |
| **Formation:** | Lines |
| **Position:** | Front Basket hold (L over R) |
| **Meter:** | 15/16 (q-q-q-q-S-q-q) |
| **Sequence:** | A. Basic |
| | B. Stamps |
| | C. HL side and front |
| | D. Scissors |
| | E. Reels |
| **Basic Steps:** | Step, bounce, stamp, scissor, reel, leap |

## Dance Description

*Meas*

**Part I** (Basic)

| | |
|---|---|
| 1 | Step R to R, step L (XIB) to R (rhythm: q-q) |
| 2 | Repeat (rhythm: q-q) |
| 3 | Step R to R (rhythm: slow) |
| 4 | Closing L to R, bounce on both feet twice (rhythm: q-q) |

5–8      Reverse Meas 1–4

9–16     Repeat Meas 1–8

**Part II** (Stamps)

1        Step R to R, Step L (XIB) to R (rhythm: q-q)

2        Repeat (rhythm: q-q)

3        Step R (While lifting L FT FWD and then circling it BK) (rhythm: slow)

4        Hop R, stamp L (rhythm: q-q)

5–8      Reverse Meas 1–4

9–16     Repeat Meas 1–8

**Part III** (HL side and front)

1        Step R to R, step L (XIB) to R (rhythm: q-q)

2        Repeat (rhythm: q-q)

3        Place R HL at R DIAG (leg is straight, lean FWD) (rhythm: slow)

4        Place R HL FWD (leg is still straight), step R in place (raising L FT slightly) (rhythm: q-q)

5–8      Reverse Meas 1–4

9–16     Repeat Meas 1–8

**Part IV** (Scissors)

1        Step R to R, step L (XIB) to R (rhythm: q-q)

2        Repeat (rhythm: q-q)

3        Place R HL at R DIAG (leg is straight, lean FWD) (rhythm: slow)

4        Place R HL FWD (leg is still straight) (rhythm: q-q slow)

5        Scissors (place L FWD, R BK, lean FWD) (rhythm q-q slow)

6        Scissors (Reverse) (rhythm: q-q slow)

7        Step BK with R FT, extend L HL to L DIAG (rhythm: slow)

8        Place L HL FWD (Leg is still straight) (rhythm: q-q slow)

9–16     Reverse Meas 1–8

### *Part V* (Reels)

1  Lift slightly on L FT, reel with R FT (bring R FT around and behind L FT, step on R) (rhythm: q-q)

2  Reverse (rhythm: q-q)

3  Drag both feet slightly BK (end on the balls of both FT) (rhythm: slow)

4  Step L, stamp R FWD (The stamp has no weight) (rhythm: q-q)

5  Step R, step L (the feet keep contact on floor and the weight shifts from R to L) (rhythm: q-q)

6  Repeat Meas 5 (rhythm: q-q)

7  Stamp R (no weight) (rhythm: slow)

8  Leap to R with R FT, stamp L beside R FT (this stamp also takes no weight) (rhythm: q-q)

9-16  Reverse entire sequence of Part V

## Additional Information

Movement is light and bouncy. The rhythm pattern is 15/16. Bend slightly FWD from the hips, keeping back straight and the head up. A good way to understand the rhythm is to stand and clap the pattern of q, q, q, q, S, q, q with the music. When you feel comfortable with the phrasing, try moving your feet to the basic step pattern.

---

## Scotland  Canadian Barn Dance

This dance is a Scottish couple mixer. It was presented at the Stockton Folk Dance Camp in 1992 by Marianne Taylor.

| | | |
|---|---|---|
| **Formation:** | Double Circle, Ptrs facing LOD |  |
| **Position:** | Inside hands held in low "V" | |
| **Meter:** | 4/4 | |
| **Sequence:** | A. Schottisches | |
| | B. Two-step turn with Ptr | |
| **Basic Step:** | Schottische, two-step | |

# Dance Description

*Meas*

1-2    Introduction

1    One schottische FWD, M begin L FT, W begin R FT (Cts 1-4)

2    One schottische BK, release hands and end facing Ptr (Cts 5-8)

3    One schottische, backing away from Ptr (Cts 1-4)

4    One schottische FWD L DIAG, meet new Ptr (Cts 5-8)

5    M and W join both hands, M steps to own L with L FT, step with R FT beside L FT, step to L with L FT, hop on L FT (W does opposite Ftwk) (Cts 1-4)

6    Repeat Meas 5 traveling opposite direction, taking closed dance position on "hop" (Cts 5-8)

7-8    Turn CW 2 times, progressing LOD, using 4 quick two-steps (or 4 low step-hops). End in original position (Cts 1-8)

**Repeat the entire dance from the beginning**

| Serbia |  | Čapkan Dimčo |
|---|---|---|

"Crazy" Dimčo was presented by Atanas Kolavovski in 1990 at Stockton Folk Dance Camp. Originally danced to singing accompaniment, it is now performed with an orchestra at weddings, festivals, picnics, etc.

| | |  |
|---|---|---|
| **Pronunciation:** | CHAHP-kahn DEEM-choh | |
| **Formation:** | Open circle, facing LOD | |
| **Position:** | Part I hands held in low "V", arms change to "W" position in Part II | |
| **Meter:** | 4/4 | |
| **Sequence:** | A. Walks | |
| | B. Čukče | |
| | C. S-q-q in place | |
| **Basic Steps:** | Walk, čukče | |

# Dance Description

*Meas*

1–4     Introduction

### Part I

1        Beginning R FT, 3 (S) walks (LOD), R, L, R (Cts 1–3)

         2 (q) walks L, R (Ct 4)

2        Repeat with opposite Ftwk (Cts 1–4)

### Part II

1        Facing center, step R, čukče R while lifting L (Cts 1–2)

         Step L (XIF), step R, čukče R while lifting L (Cts & 3–4)

2        Repeat with opposite Ftwk (Cts 1–4)

### Part III

1        In place, step R (S), L (q), R (q), dropping weight on first step (Cts 1–2 &)

         Step L (S), R (q), L (q) (Cts 3–4 &)

2        Step R, čukče R, step L (XIF) (Cts 5–6 &)

         Step R (S), L (q), R (q) (Cts 7–8 &)

3–4     Reverse Meas 1–2 (Cts 1–8)

**Repeat the entire dance from the beginning**

# Mexico  Corrido

The Mexican Corrido was introduced to the Folk World by Avis Landis. Corrido developed from a folk ballad and has many typical Mexican steps, such as soldado, step-close, and grapevine.

**Pronunciation:** KŌH-ree-doh
**Formation:** Double Circle, Ptrs facing each other
**Position:** Closed or Semi open
**Meter:** 4/4
**Sequence:**

| I | II | III |
|---|---|---|
| A. 10 Step-close steps | A. 10 Step-close step | A. 10 Step-close steps |
| B. Basic grapevine | B. Cross step and turn | B. Basic grapevine |
| C. 4 Step-close steps and Soldado | C. 4 Step-close steps and Soldado | C. 4 Step-close steps and Soldado |
| D. Basic grapevine | D. Variation grapevine | D. Basic grapevine, holding inside hands |

*M's Ftwk is described. W's Ftwk is opposite to M's.
M always begins with the R FT.

**Basic Steps:** Step-close, grapevine, walk

## Dance Description

*Meas*

Introduction

### Part I (Step-close)

1–5     M begins R FT, W begins L FT traveling R LOD, do 10* step-close steps. (Step to R with R FT on Ct 1, step beside R FT with L FT on Ct 2) (Cts 1–20)

*On the tenth step-close step, remember to put weight on L FT, so that R FT is free for next step

### Part II (Basic grapevine)

1–7     M begins XRIF, W begins XLIF. Do 7 basic grapevines traveling LOD (Cts 1–28)

8       M XRIF, step L with L FT, stamp R FT beside L FT, hold Ct 4 (Cts 1–4)

### Part III (Step-close, Soldado)

1–2     (Interlude) M BK to center, do 4 step-close steps RLOD (Cts 1–8)

1      (Soldado) M BKs into center doing 4 walking steps starting on R FT (Cts 1-4)

2      M travels FWD diagonally L out of center doing 4 walking steps (Cts 1-4)

3-8      **Repeat Meas 1-2, 3 more times.** The last time when M comes FWD away from center, M does 3 stamps L, R, L. Hold 4th Ct (Cts 1-24)

1-8      **Repeat Part II** (Cts 1-32)

### SECOND TIME THROUGH DANCE

1-5      **Repeat Part I** (Cts 1-20)

### Part IV (Cross-step and Turn)

1      Facing Ptr, M XRIF of L FT (lifting L FT slightly off floor), step BK in place with L FT, step with R FT beside L FT, XLIF of R FT (lifting R FT slightly off floor). M put hands behind BK, W hold skirt (Cts 1-4)

2      Do a 4-step R turn, beginning with R FT stepping behind L FT. M turn L, W turn R (Cts 1-4)

3-8      **Repeat Meas 1-2, 3 more times.** On Meas 8, stamp 3 times and hold Ct 4 (R, L, R) (Cts 1-24)

1-8      **Repeat Part III** (Cts 1-32)

### Part V

1-2      Face LOD DIAG and join M's L hand with W's R hand. M do a continuous basic grapevine traveling LOD. W do 1 Meas of basic grapevine, then next Meas does 2 turns to R arching under M's L arm (Cts 1-8)

3-8      **Repeat Meas 1-2, 3 more times** (Cts 1-24)

### THIRD TIME THROUGH DANCE

1-5      **Repeat Part I** (Cts 1-20)

1-8      **Repeat Part II** (Cts 1-32)

1-8      **Repeat Part III** (Cts 1-32)

     **Repeat Part V** with a variation. Holding inside hands, do the grapevine, swinging hands FWD as the R FT XIF (for M, L FT for W), and swinging the hands BK as the FT XIB. End the dance by stamping 2X's (L, R) and lifting free hand overhead.

## Additional Information

**Styling:** Movement is energetic and lively. During step-close step, the torso should move from side to side with extended arms in closed position lifting up on first step. There should be a "fun": interaction between partners.

**Semi open Position:** This position is similar to closed position except that instead of facing each other, the couple opens slightly and faces the direction of travel.

# United States  Cotton-Eyed Joe

The "Cotton-Eyed Joe," a popular American folk dance, came from Texas around the 1880s. It emphasizes the heel and toe polka, which originally came from clog steps.

| | | |
|---|---|---|
| **Formation:** | Mass, traveling LOD with partner | |
| **Position:** | Elongated arms | |
| **Meter:** | 2/4 | |
| **Sequence:** | A. Heel-Toe Polka LOD, then RLOD | |
| | B. Individual turn, 3 stamps | |
| | C. Push steps | |
| | D. Polka LOD with Ptr | |
| **Basic Steps:** | Heel-toe, polka, push step | |

## Dance Description

*Meas*

Introduction (Hold 3 counts after the singing)

### *Part I*

1-2     Heel-toe (M L, W R) one polka (LOD) (Cts 1-4)

3-4     Reverse 1-4 (RLOD) (Cts 5-8)

### *Part II*

1-3     Dropping hands, each takes 3 polka steps turning in one small individual circle (M L, W R) (Cts 1-6)

4       3 stamps facing Ptr (M R, L, R, and W, L, R, L) (Cts 7 & 8)

### *Part III*

1-2     4 push-steps (LOD) (M L, W R) (Cts 1-4)

3-4     4 push-steps (RLOD) (Cts 5-8)

### *Part IV*

1-4     4 polka steps with Ptr (take closed dance position moving LOD, turning CW) (Cts 1-8)

**Repeat the entire dance from the beginning**

# England  Cumberland Square

Cumberland Square is a well-known dance from Cumberland, a county in Northwest England on the Scottish border.

| | |
|---|---|
| **Formation:** | Four couple square, couples facing center of square |
| **Position:** | No Contact |
| **Meter:** | 4/4 |
| **Sequence:** | A. Slide across and back |
| | B. Star |
| | C. Basket |
| | D. Circle and promenade |
| | E. Acknowledgment: Bow or curtsey |
| **Basic Steps:** | Slide, walk, skip |

**HEAD OF HALL**

## Dance Description

*Meas*

Introduction (Long note to honor Ptr)

### Part I

1-2     Head couples (1 & 3), take *elongated arm position and slide 8 Cts changing places (M pass BK to BK)

   *elongated arms: face each other and hold hands, extending arms out to sides

3-4     Head couples (1 & 3) slide 8 Cts and return home (W pass BK to BK) (Cts 9-16)

5-8     Side couples complete the same figure (Cts 1-16)

9-16    **Repeat Meas 1-8** (Cts 1-32)

### Part II

1-2     Head couples walk 8, forming a R-hand star (CW)

3-4     Head couples change to a L-hand star (CCW), return to home position on Ct 8 (Cts 9-16)

5-8       Side couples complete the same figure (Cts 1–32)

9-16     **Repeat Meas 1-8** (Cts 1–32)

### Part III

1-4       Head couples circle CW with 16 rida steps, beginning R (XIF). Form a basket with M's arms around both W's waists, W's hands on M's closest shoulders

5-8       Side couples complete the same figure (Cts 1–16)

9-16     **Repeat Meas 1-8** (Cts 1–32)

### Part IV

1-4       Hands held in "V" low and circle CW with 16 skips, start on R FT

5-8       M and W link inside arms and promenade home (CCW) with 16 walking steps (Cts 17–32)

9-16     **Repeat Meas 1-8** (Cts 1–32)

## Additional Information

The basket in Part III can also be formed by W linking elbows with both M. If a couple is not dancing while in the square, they simply stand in place and observe the other couple.

## Hungary  ◆  Czardas Vengerka

The very popular Czardas from Hungary has many variations. Andor Czompo introduced this favorite couple dance.

| | |
|---|---|
| **Pronunciation:** | CHAR–dahsh Vehn–GEHR–kan |
| **Formation:** | Double Circle, Ptrs facing LOD |
| **Position:** | Varsouvienne |
| **Meter:** | 4/4 |
| **Sequence:** | A. Step-close and Hungarian break step |
| | B. Reel, walk, turn |
| **Basic Steps:** | Czardas, Hungarian break step, reel, walk |

# Dance Description

*Meas*

1-2    Introduction (Cts 1-8)

### Part I

1    Moving DIAG FWD to R, step R, close L to R, step FWD R, close L to R (Cts 1-4)

2    Hungarian break step (also known as a Bokazo) (Cts 5-8)

3-4    Repeat Meas 1-2 going to L with L Hungarian break step (Cts 1-8)

5-8    **Repeat Meas 1-4** (Cts 1-16)

### Part II

1    Ptrs face, M's BKs to center, hands on waist. Do 4 reel steps BK, R, L, R, L, moving away from Ptr (Cts 1-4)

2    Hungarian break step (Cts 5-8)

3    Make a complete R turn in a small circle with 4 walking steps, finish facing Ptr (Cts 1-4)

4    Hungarian break step (Cts 5-8)

5    Move toward Ptr, step R (S), step L (S), stamp R-L (qq), stamp R (S) (put no weight on FT) (Cts 1, 2, 3, & 4)

6    Hungarian break step (Cts 5-8)

7    Make individual circle, CW, walking R, L, R, L. End by Ptr, facing LOD (Cts 1-4)

8    Hungarian break step, end in varsouvienne position (Cts 5-8)

**Repeat the entire dance from the beginning**

# Macedonia  Da Mi Dojde

This is a popular folk song and dance from Macedonia. It translates to "so that you will come to me." Jaap Leegwater presented it at the 1991 Idyllwild Folk Dance Camp in California.

| | |
|---|---|
| **Pronunciation:** | dah-mee-DOY-dehsh |
| **Formation:** | Open circle, facing LOD |
| **Position:** | Hands held at shoulder height in "W" |
| **Meter:** | 2/4 |
| **Sequence:** | A. Walk, Čukče |
| | B. Turn to face BK, then FWD |
| | C. Hop–step steps |
| **Basic Step:** | Walk, čukče, hop |

## Dance Description

*Meas*

1–16   Introduction (Cts 1–32)

**Part I**

1   Moving LOD, step R, step L (Cts 1–2)

2   Step R, ĉukĉe, (Cts 3–4)

3   Step L, ĉukĉe, (Cts 5–6)

4   Step R, ĉukĉe, (Cts 7–8)

5–8   **Reverse Cts 1–8** (Cts 9–16)

9–12   **Repeat Meas 1–4 moving toward center, then do Meas 5–8 in place** (Cts 1–8)

13–16   **Repeat and Reverse Meas 1–8 backing out from center** (Cts 9–16)

**Part II**

1   Step FWD R (clap both hands reaching FWD), step BK on L (Cts 1–2)

2   Step R next to L and turn R 1/2 hop on R while lifting L (Cts 3–4)

3–4   **Reverse Cts 1–4** (Cts 9–16)

5–8      **Repeat Part I, Meas 1–4** (Cts 9–16)

9–16    **Reverse Meas 1–8** (Cts 1–16)

### Part III

1        Moving LOD, hop L, step R, step L (Cts 1 & 2)

2        **Repeat Meas 1** (Cts 3 & 4)

3        Step R, L, R (Cts 5 & 6)

4        Step L, R, L (Cts 7 & 8)

5–6      **Repeat Meas 1–2** (Cts 1–4)

7        Step R, L, R (Cts 5 & 6)

8        Step L (XIF), step R (Cts 7–8)

9–16    **Reverse and Repeat Meas 1–8** (Cts 1–16)

**Repeat the entire dance from the beginning**

## Additional Information

The dancer should execute a light, easy bounce with each step. The styling and mood is carefree and pleasant.

| Israel | ◆ | Debka Shachar |
|---|---|---|

"Debka Shachar" translates to mean "Dance of the Dawn." This dance has received its influence from the stylized dances of the Arabs, with movements that have a vertical bounce. Strength and power, self-confidence and pride reflect the Israeli culture.

| | |
|---|---|
| **Pronunciation:** | DEB-kah Shah-KAHR |
| **Formation:** | Lines, facing LOD |
| **Position:** | Hands held in low "V" |
| **Meter:** | 4/4 |
| **Sequence:** | A. Debka grapevine |
| | B. Step–hops, two-steps, drops |
| | C. Yemenite interlude |
| | D. Rock and claps |
| | E. Stamp, hops back |
| **Basic Steps:** | Debka, hop, yemenite, stamps |

# Dance Description

*Meas*

1-24     Introduction (Cts 1-16)

**Part I**

1     Step R to R sd, step L XIF of R (Cts 1-4)

2     Step R to R, facing center, then step L behind R (Cts 5-8)

3     Step R to R (Cts 1-2)
      Touch L in front of R (Cts 3-4)

4     Yemenite starting L FT (Cts 5-8)

5-8     **Repeat Meas 1-4** (use a slight bounce in the knee) (Cts 1-16)

**Part II**

1     Step R (1), hop on R (2), moving FWD R DIAG, L leg raised and bent at knee, then three
      small running steps beginning with L FT (3 & 4)

2     **Repeat Meas 1** (Cts 5-8)

3     Balancé FWD on R (Cts 1 & 2), balancé BK on L (Cts 3 & 4)

4     Drop on R with L leg lifted and bent at the knee (Ct 1), step on L (Ct 2). Repeat (Ct 3 & Ct 4)

5-8     **Repeat Meas 1-4**

**Part III** (Interlude—face center)

1-2     Yemenite R (Cts 1, 2, 3, hold 4), yemenite L (Cts 5, 6, 7, hold 8)

**Part IV**

1     Touch R toe while turning R hip to center (clap hands chest high at same time as touch). Lift
      R FT slightly off ground, releasing weight onto L leg. Repeat (Cts 1-4)

2     Yemenite, stepping BK with R, face center (Cts 5, 6, 7, hold 8)

3-4     **Repeat Meas 1-2 reversing Ftwk (touch L FT, turn L hip to center, etc.)** (Cts 1-8)

5-8     **Repeat Meas 1-4** (Cts 1-16)

**Part V**

1     In a simple hand hold, stamp R across L with bent knee (Ct 1). Body leans FWD, Hold (Ct 2).
      2 hops BK on R (L lifted in BK, both knees bent) (Cts 3-4)

2 Yeminite, stepping BK DIAG with L (Cts 5-8)

3-4 **Repeat Meas 1-2** (Cts 1-8)

**Repeat entire dance from the beginning**

## Additional Information

The styling of Yemenite has a continual bounce with each step. The dance should be done with ease, yet also with a solid shifting of weight on certain steps.

## Germany ◆ D'Hammerschmiedsg'selln

This North Bavarian dance was danced by both men and women in a recreational setting. The translation of this dance is "the journeyman blacksmith," which represents the occupation of the blacksmith in the village setting.

**Pronunciation:** dah-HAHM-er-schmeetz-gah-ZELL-ehn
**Formation:** Couples facing each other
**Position:** No contact, arms held down by side
**Meter:** 3/4
**Sequence:** A. Clapping sequence (Ptrs)
B. Small circle
C. Clapping sequence (M)
D. Star
E. Clapping sequence (W)
F. Large circle
**Basic Steps:** Step-hops

**Clapping Sequence:**

| Counts | Action |
|--------|--------|
| 1 | Slap own top of thighs with both hands, knees slightly bent* |
| 2 | Slap own shoulders, straightening legs* |
| 3 | Clap own hands together |
| 4 | Slap R hands with opposite person |
| 5 | Slap L hands with opposite person |
| 6 | Slap both hands with opposite person |

*A quick turn may be done on Cts 1 & 2 while performing the hand actions.

# Dance Description

*Meas*

1–4     Introduction (Cts 1–12)

### Part I

1–16    Clapping sequence repeated 8 times. Couple 1 faces each other (Cts 1–48)

### Part II

1–8     Join with another couple and circle CW with 8 step-hops, beginning with R (Cts 1–24)

9–16    Same as Meas 1–8, reverse to CCW (Cts 1–24)

### Part III

1–16    Clapping sequence repeated 8 times (M1 and M2 start, W1 and W2 holds 3, then begins) (Cts 1–48)

### Part IV

1–8     All four face CW and raise R hands in the middle to make a star. Do 8 step-hops, starting with R FT (Cts 1–24)

9–16    Same as Meas 1–8, reverse direction, joining L hands in a star, moving CCW (Cts 1–24)

### Part V

1–16    Clapping sequence repeated 8 times (W1 and W2 start, M1 and M2 hold 3, then start) (Cts 1–48)

### Part VI

1–8     Groups of 4 open to join hands in one large circle with other groups. Step-hop CW beginning R (Cts 1–24)

9–16    Reverse direction and step-hop CCW ending the dance with hands raised (Cts 1–24)

## Czech Republic  Doudlebska Polka

"Doudlebska Polka" is an authentic traditional mixer. Jeannet Novak introduced the dance at the Herman's Folk Dance House located in New York in 1956. The name of the dance means a "polka from Doudleby," which is a small village in South Bohemia.

| | |
|---|---|
| **Pronunciation:** | DOHD-lehb-skah POH-kah |
| **Formation:** | Couples in mass formation, traveling LOD |
| **Position:** | Shoulder-waist |
| **Meter:** | 2/4 |
| **Sequence:** | A. Polka |
| | B. Walk and sing |
| | C. M clap, W circle |
| **Basic Steps:** | Polka, walk |

## Dance Description

*Meas*

None   Introduction

### Part I

1–16   Do 16 polka steps, turning CW, moving LOD around the hall (Cts 1–32)

### Part II

17–32   In open position, M places extended L arm on L shoulder of M in front as couples walk LOD. This will form a ring of dancers in the center of the room. W free hand on hip and L hand on M's R shoulder. Everyone sings "Tra-la-la . . ." to the melody of the music (Cts 1–32)

### Part III

33–48   M face center of circle, clap own hands 2 times (Cts 1 &), clap hands of M once on both sides shoulder high (Ct 2). Repeat 7 more times. W circle CW with 16 polka steps, progressing FWD around outside of circle. W dance with the M they end up behind on the last Meas (Cts 1–16)

### Repeat the entire dance from the beginning with new Ptr

## Additional Information

Part II may be performed in several smaller stars if a very large group is participating. W then circle around the smaller circles as described in Part III.

# Romania  Hora de Mîna

This dance was taught by Nicolaas Hilferink at a workshop in Denver, Colorado, in 1989. The dance is from the region Oltenia. Mîna means "hand."

| | |
|---|---|
| **Pronunciation:** | HOH-rah day MUH-nuh |
| **Formation:** | Lines |
| **Position:** | Modified "W" for Part I, Little Fingers held, (see Part I for description) |
| **Meter:** | 2/4 |
| **Sequence:** | A. Side to side touches |
| | B. Walk and cross |
| | "Interlude" |
| | C. Two-steps, walk back |
| **Basic Steps:** | Step touches, walk, two-steps, pas de basques |

## Dance Description

*Meas*

None    Introduction

### Part I

1-2    Step R to R, close and touch L to R, reverse. Arms held shoulder height, L arm bent with elbow high, R arm straight. Extend to R side on Cts 1-2, reverse on Cts 3-4. Continue to hold little fingers (Cts 1-4)

3-4    Step R to R, step L to R, step R to R, close and touch L to R (Cts 5-8)

5-8    Reverse Cts 1-8

9-16    Repeat Meas 1-8 once more (Cts 1-16)

### Part II

1-2    Walk FWD R, L, cross R over L, step L in place. Arms "W" position (Cts 1-4)

3-4    Walk BK R, L, kick R, step R in place (Cts 5-8)

5-6    Step L, kick R, step R in place, step L (Cts 1-4)

7-8    Cross R over L, step L, kick R, step R (Cts 5-8)

1-8    Repeat Meas 1-8 with opposite Ftwk (kicks are done on Cts 7, 10, 15)

**Interlude**

1-2    Walk to R FWD DIAG R, L, R, close L to R (turn to face L DIAG) (Cts 1-4)

**Part III**

1-2    2 two-steps to FWD L DIAG, starting R FT (arms swing down on the first Ct, and extend straight up over head on the second) (Cts 1-4)

3-6    Walk BK DIAG 8 steps, starting R. Arms lower to "W" position on first 4 Cts, then bounce on Cts 5, 6, 7, 8

7-8    Facing FWD, do 2 flat-footed pas de basques, R and L. Arms swing down on first Ct, and to "W" position on second Ct (Cts 1-4)

1-8    Repeat Meas 1-8 Part III (Cts 1-16)

**Repeat Part II**

**Repeat entire dance from the beginning**

## United States  Jacob Hall's Jig

"Jacob Hall's Jig" is a Contra dance, which has lines of many couples. This particular dance is known as a Duple proper. The dance is performed by "2 couple" units within the Contra set.

| | |
|---|---|
| **Formation:** | 4 couples in longways set, M to R of caller, W to L |
| **Position:** | No contact |
| **Meter:** | 4/4 |
| **Sequence:** | A. Active M—Allemande R & L, circle three<br>    Inactive M—Allemande L & R, circle three<br>B. Actives down the center & BK, up the center four in a line<br>C. Circle four once around L & cast off |
| **Basic Step:** | Walk (Both M and W begin with the R FT)<br>*Allemande: Take R or L forearm hold with designated person and walk around each other one full turn. |

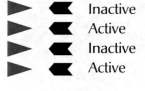

CALLER

# Dance Description

Meas

### *Part I*

1        Active M allemande R with W below (Cts 1-4)

2        Active M allemande L with Ptr (Cts 5-8)

3-4     Both W and active M circle R once around to home (Cts 9-16)

5        Inactive M allemande L with W above (Cts 17-20)

6        Inactive M allemande R with Ptr (Cts 21-24)

7-8     Both W and inactive M circle L once around to home (Cts 25-32)

### *Part II*

1        Active couples join inside hands and walk down the center (Cts 1-4)

2        Active couple turns toward each other and moves up the center joining hands with inactive couple (Cts 5-8)

3-4     All four are in a line moving up the center (4 walks FWD), and walk backwards down the center (4 walks BK) (Cts 9-16)

### *Part III*

1-2     The line of four circles L once around, 8 walks (Cts 1-8)

3-4     Active M stays joined with inactive M, active W stays joined with inactive W. Both actives walk FWD 8 Cts pivoting a 3/4 turn or casting off. Active couples end one position below with both couples facing their Ptrs (Cts 9-16)

## Additional Information

Each couple is labeled "inactive" or "active." The "inactive" couple progresses up the set, and the "active" couple progresses down the set which is away from the music. When the "active" couple reaches the bottom of the set, they will wait once through the dance (for a duple minor) before entering the set again. When they re-enter, they will become an "inactive" couple. The "inactive" couples will also do the same thing when reaching the top of the set, reentering as an "active" couple.

```
O    X    Inactive
O    X    Active
O    X    Inactive        Active    ↑   progresses down the set
O    X    Active
O    X    Inactive        Inactive  ↓   progresses up the set
O    X    Active

Caller
  X
```

# Macedonia  Jovano Jovanke

"Jovano Jovanke" is a choreographed movement pattern or form of a "Lesnoto" (a well-known type of dance done in the regions of Macedonia) as danced in the town of Krushevo, Macedonia. It is also known as "De Maro Selfio." Michel Cartier of Montreal, Canada, learned it in Sophia in 1958. Richard Crum presented it at University of the Pacific Folk Dance Camp, 1959.

**Pronunciation:** YOH-vah-no YOH-vahn-keh
**Formation:** Open Circle, facing center. All M should be at R end of line, W are to the L of the M in a line. The M are connected to the W by a handkerchief. The leader (the first M on the R end) holds a handkerchief and waves it in the air to indicate a pattern change.
*M and W can mix with each other in the line, using the "T" hold.
**Position:** W—hands held at shoulder height in "W"
M—Shoulder to shoulder in "T"
**Meter:** 7/8
**Sequence:** A. Lesnoto LOD
B. Into center and out
**Basic Step:** Čukče, basic walking steps

## Dance Description

*Meas*

8        Introduction

         ***Part I Danced to Vocals***

1        Step to R with R, facing DIAG (Ct 1 Slow)

         Raise R HL while bringing L across in front of R (Ct 2 q)

         Step on L FWD and to R of R FT (Meas 1 is known as a čukče) (Ct 3 q)

2        Step to R with R, turning to face center (Ct 1 Slow)

         Swing L up in front of R with knee bent (M higher than W). At same time raise up R HL and come down (Ct 2 q)

         Keeping lifted L leg in place, raise R HL again and come down (Ct 3 q)

3        Reverse Meas 2

4-21     Repeat Meas 1-3 seven more times

***Part II*** (Into center and out, starts on last Meas of vocal and continues through instrumental)

22       Step R next to L (Ct 1)

         Step L in place (Ct 2)

         Step R in place (Ct 3)

23       Step L toward center (Ct 1)

         Step R toward center (this is a shorter step than the step L on ct 1) (Ct 2)

         Step L next to R (Ct 3)

24       Step BK DIAG R on R (Ct 1)

         Raising and lowering R HL, cross L behind and to R of R HL, toe close to floor (Ct 2)

         Put full weight on L (Ct 3)

25-30    Repeat Part II two more times

## Additional Information

The feeling or mood of the singing and the musical accompaniment encourages the lightness and ease with which each step is executed. There should always be a soft bounce or lifting motion with each movement. The men lift their legs much higher than the women. At times the women's foot is only slightly off the floor. Because of this difference in styling, the separation of men and women in the line is preferred by many dancers.

## Song Text

Jovano, Jovanke                          Jovana, you sit by the Vardar
Kraj Vardarot Sediš mori                 Bleaching your white linens
Belo platno Beliš                        And looking up at the hills.
Belo platno beliš dušo
Se na gore gledaš

Jovano, Jovanke                          Jovana, I wait for you to come up
Jas tebe tečekam mori                    Me, but you don't come, my dear.
Doma da mi dojdeš,
A tin ne do vadjaš dušo
Srce moje jovano

Jovano, Jovanke                          Jovana, your mother doesn't let
Tvojata majka mori                       You come to me, my sweetheart.
Tebe ne te pusta
So mene da dojdeš dušo
Srce moje Jovano

This song comes from the town of Kruševo in west central Macedonia. People would take their newly woven linen (which was always yellowish) to the riverside. There they would wash and sun-bleach the linen to whiten it. This domestic chore doubled as a social opportunity with other villagers.

# Serbia  Kolubarski Vez

This dance was presented at the 1991 Idyllwild Folk Dance Camp in California by Slobodan Slovic. It is danced in Western Serbia.

**Pronunciation:** KOH–looh–bar–skee Vehz
**Formation:** Lines
**Position:** Hands held in low "V"
**Meter:** 2/4
**Sequence:** A. Walking
B. Hop, walks, sideways step
C. Step dots, kicks BK, HLs
D. Hop, walks, out–in step
**Basic Steps:** Walk, touch, hop, step dot

## Dance Description

*Meas*

None     Introduction

**Part I**

1–4      Moving to the R DIAG, walk R, L, R, touch L with flat FT (end facing L DIAG). Reverse to L (Cts 1–8)

5–16     Repeat Meas 1–4, 3 more times (Cts 1–24)

**Part II**

1–2      Traveling and facing R DIAG hop L and step R, step L (XIF), step R, touch L to R FT (end facing front) (Cts & 1–4)

3–4      Moving L without turning body, step L, close R to L (Ct &) step L, close R (Ct &), step L, close R (Ct &), step L (Cts 5–8)

5–16     Repeat Meas 1–4, 3 more times (Cts 1–24)

**Part III**

1–2      Small running step in place R, L, R. L. The free FT dots in BK with each step (L, R, L, R) (Cts 1–4)

3          Small running step in place R, L. Free FT kicks up in the BK (L, R) (Cts 5-6)

4          Weight on both HLs, hold 2 Cts (Cts 7-8)

5-16       Repeat Meas 1-4, 3 more times (Cts 1-24)

**Part IV** (not done first time through dance)

1-2        Traveling and facing R DIAG hop L (Ct &) and step R (Ct 1), step L XIF (Ct 2), step R (Ct 3), touch L to R FT (end facing front) (Ct 4)

3-4        Step L to L (Ct 5), step R in place (Ct &), close L to R with wgt. on L (Ct 6), step R in place (Ct &), step L to L (Ct 7), step R in place (Ct &), close L to R (Ct 8)

5-16       Repeat Meas 1-4, 3 more times (Cts 1-24)

## Additional Information

Pattern: Parts I, II, & III, then the rest of the dance continues I, II, III, IV, I, II, III, IV, . . . . On Part IV, Meas 1 & 3, Cts 5-8, M repeat the words, "Opa Opa Opa Ha." On Part IV, Meas 2 & 4, Cts 5-8, W repeat the words, "Naka Naka Naka Ga."

| Norway | Komletrø |
|--------|----------|

"Komletrø" is a very simple mixer introduced by Alix Cordray at the Stockton Folk Dance Camp in 1992. She learned the dance from Torleiv Molaug of Stavanger, Norway. "Komle" is a dialect word for a large potato dumpling, while "trø" means step. This mixer can be done to any fast mazurka with regular phrasing.

**Pronunciation:** kohm-LEH-troy
**Formation:** Double Circle, Ptrs facing LOD
**Position:** Promenade
**Meter:** 4/4
**Sequence:** A. Run FWD and BK
              B. Couples rotate, reverse
              C. W arch, M turn and progress
**Basic Steps:** Easy run

# Dance Description

*Meas*

1–2    Introduction (Cts 1–8)

### Part I

1–4    Starting on outside FT (M L, W R), run FWD (Cts 1–16)

5–8    Continue facing LOD, run BK (Cts 1–16)

### Part II

1–2    Continuing run, couples wheel CW (M FWD first and W BKWD) (Cts 1–8)

3–4    Couples wheel CCW (M BK and W FWD) (Cts 9–16)

### Part III

1–2    Releasing L hands, M & W raise R hands, W turns CW twice under arch. M continue to run FWD, while the W turns (Cts 1–8)

3–4    M claps on Ct 1, turning L once and moving FWD to next W. W continue to run in place (Cts 9–16)

**Repeat the entire dance from the beginning with new Ptr**

**Additional Information**

The run is grounded yet light-hearted. M leads by pulling and pushing slightly with his R arm. Arms are slightly bent at the elbow. To wheel quickly, couples face each other slightly and lock arms at the elbows. M pulls his L hand while pressing his R arm against the inside of the W's bent elbow. The styling is light, with little effort.

# Russia  Korobushka

"Korobushka" translates as "a little basket." According to Michael Herman, the dance originated from a group of Russian immigrants in the United States following World War I. It has now become one of the most popular Russian dances among folk dancers around the world.

| | |
|---|---|
| **Pronunciation:** | Koh-ROH-boosh-kah |
| **Formation:** | Double Circle, Ptrs facing each other, M'S bk to center |
| **Position:** | Two hands joined waist height |
| **Meter:** | 2/4 |
| **Sequence:** | A. Schottische, bokazo |
| | B. Turn R, balancé and change places with Ptr |
| **Basic Steps:** | Schottische, bokazo, balancé, walk |

## Dance Description

*Meas*

**1–8**    Introduction (Cts 1–16)

### Part I

**1–2**    M 1 schottische FWD while W do 1 schottische BK (M L, W R) (Cts 1–4)

**3–4**    M 1 schottische BK, W 1 schottische FWD (Cts 5–8)

**5–6**    Repeat Cts 1–4

**7–8**    Bokazo (Cts 13–16)

### Part II

**1–2**    Three-step turn, clap on Ct 4. Turn R 1 full individual turn, hands on waist, starting on R FT (Cts 1–4)

**3–4**    Reverse Cts 1–4 (Cts 5–8)

**5–6**    Joining R hands with Ptr, balancé FWD, balancé BK (Cts 1–4)

**7–8**    Change places with Ptr. M walk FWD 4 steps while raising R hand. W turn CCW under arch with 4 walking steps (Cts 5–8)

**1–8**    Repeat Meas 1–8, M on outside of circle, W with BK to center of circle (*When turning L, remember to stay in place. This will allow the changing of Ptrs) (Cts 1–16)

**Repeat the entire dance from the beginning**

## Additional Information

This dance becomes a delightful mixer by having the dancers complete the last three-step turn in place. They then balancé and continue the dance with a new Ptr. Whenever a hand is free, it should be placed on the waist in a fist, wrists straight. The upper body is lifted with the shoulders held back, head high.

| **Ukraine** ◆ **Kosa** |
|:---:|

"Kosa," choreographed by Colleen West, is composed of basic Ukrainian steps from the Poltavskyi region, which is located in central Ukraine. The styling is very lifted, controlled, and poised.

| | |
|---|---|
| **Pronunciation:** | KOH-sa |
| **Formation:** | Double Circle, Ptrs facing each other |
| **Position:** | No contact, hands on waist, fingers FWD |
| **Meter:** | 4/4 |
| **Sequence:** | A. Side, together, side, stamp |
| | B. Toe-heel, prytup |
| | C. Holubchuk with walking step |
| | D. Heel, step behind, turn, HL, prytups |
| **Basic Steps:** | Steps, toe-heel, prytups, holubchuk |

## Dance Description

*Meas*

1-10      Introduction (Cts 1-40)

**Part I**

1      Step to R with R, close L to R FT, step to R with R, stamp L next to R (Cts 1-4)

2      Reverse Cts 1-4, moving to L (Cts 5-8)

3-4      Repeat Cts 1-8 once more (Cts 9-16)

**Part II**

1      Place R toe to R side (Ct 1) with the toe and knee turned in. Replace R toe with R HL on floor, toe turned out (Ct 2). Prytup (Cts 3 & 4)

2      Reverse Cts 1-4, starting with L (Cts 5-8)

3-4      Repeat Cts 1-8 once more (Cts 9-16)

### *Part III*

1-2    With R sides together, R arms around waists, Ptrs walk around each other, L arm raised. BK away, clap on Ct 8 (Holubchuk) (Cts 1-8)

3-4    Repeat Cts 1-8, with L sides together, L arms around waists, R arm raised (Cts 9-16)

### *Part IV*

1-2    Step on R HL to R side, step behind with L, Prytup. Repeat to L (Cts 1-8)

3      Turn R 1 full turn with 2 walking steps, R, L, then Prytup (Cts 1-4)

4      Step FWD onto L HL, step BK with R, Prytup (will be facing new Ptr) (Cts 5-8)

### **Repeat the entire dance from the beginning**

### Additional Information

Hands on waist, fingers FWD and closed together, wrists locked. The upper body is lifted and poised, with precision in arm and foot movement. During the Holubchuk, couples should lean slightly away from each other while keeping eye contact.

## Canada    La Bastringue

In northern France, "La Bastringue" was the name peasants used for their gatherings, festivals, or balls. This dance was brought over 300 years ago to the province, Quebec in Eastern Canada. Many French-Canadian dances were performed indoors, therefore small groups were used in such formations as a square and all figure patterns were kept orderly and confined. The dance enables every man to dance with every woman in the circle. The dance was collected by Jean Trudel.

| | |
|---|---|
| **Pronunciation:** | lah-bah-STREENG |
| **Formation:** | Single Circle, facing center, Ptrs with W on L side of M |
| **Position:** | Hands held at shoulder height in "W" |
| **Meter:** | 4/4 |
| **Sequence:** | A. Walk FWD and touch, walk BK and touch |
| | B. Two-steps to L and R |
| | C. M turn W under and swing |
| | D. Two-step LOD with Ptr |
| **Basic Steps:** | Walk, two-step, buzz turn |

# Dance Description

*Meas*

1-5     Introduction (Cts 1-20)

### Part I

1       Facing center walk FWD R, L, R, touch L to R (Cts 1-4)

2       Walk BK L, R, L, touch R to L (Cts 5-8)

3-4     Repeat Cts 1-8 (Cts 9-16)

### Part II

1-2     Beginning R FT, face CW and do 4 two-steps (Cts 1-8)

3-4     Reverse direction and do 4 two-steps CCW (Cts 9-16)

### Part III

1       M remains facing center as he leads W on L toward center with L arm, W take 2 steps, R, L (Cts 1-2)

        M raise L arm, W turn under once R turn with 2 steps, R, L (Cts 3-4)

2-4     Swing Ptr in closed position doing a buzz turn, Quebec style. W end on the R of the M, all facing LOD (M's R arm around W's waist, W's L hand on M's R shoulder) (Cts 5-16)

### Part IV

1-4     Couples do 8 two-steps LOD. On Cts 15-16 M brings W to face center so that all are in a single circle again. M will have a new W on his L for his Ptr (Cts 1-16)

**Repeat the entire dance from the beginning**

## Additional Information

A.      "Quebec Style" swing on the buzz turn is executed very smoothly with no bouncing. Couples face each other and extend arm out to side (M's L, W's R).

# Mexico  La Raspa

This dance is often done as a form of celebration and uses basic Mexican steps. It is a fun mixer where partners chain down the line four partners before they repeat the dance again.

| | |
|---|---|
| **Pronunciation:** | LA Ras-pa |
| **Formation:** | Double Circle, Ptrs Facing |
| **Position:** | Two-hand position waist high |
| **Meter:** | 2/4 |
| **Sequence:** | A. Kicking and clap |
| | B. |
| **Basic Steps:** | Kicking step and walk |

## Dance Description

*Meas*

### Introduction

### *Part I (Kicking step)*

1–4    Beginning R, kick, RLR as changing feet, on ct 4 clap hands 2 X's chest height
\*See description of step at end of dance

5–8    Turn slightly from Ptr ( R shoulders to R shoulders) and repeat 1–4

9–12    Turn slightly from Ptr (L shoulders to L shoulders) and repeat 1–4

13–16    Repeat 1–4 facing Ptr

### *Part II (Chain)*

1–4    With Ptr hook R elbows and swing one and a half around with outside arm held high and take eight quick running steps

5–8    Each move one partner to own R (M CW and W CCW) and hook L elbows with new partner and swing around with outside arm held high and take eight quick running steps

9–12    Moving to own right to new Ptr again repeat 1–4

13–16    Moving to own right to new Ptr again repeat 5–8

### Repeat the entire dance from the beginning until the music ends

## Additional Information

**Styling:** The movement is lively and fun with social interaction between couples.

**Kicking step:** The kicking step can also be called a "Bleking step" and is described as follows: Standing on L do slight hop on L as kick R heel forward, do small leap to R and kick L heel forward, do small leap to L and kick R heel forward and hold as clapping two times. Reverse step. The heel forward is done on the accented beat of music.

# Ukraine  Metelytsia

"Metelytsia" means "snowstorm or blizzard." The name is reflected through the choreography such as fast changes of step patterns, figures, or turns. This dance was choreographed by Colleen West in 1992 and is from the Poltava region.

| | |
|---|---|
| **Pronunciation:** | meh-thl-LEET-see-ah |
| **Formation:** | Double Circle, Ptrs facing each other |
| **Position:** | No contact, hands on waist, fingers FWD |
| **Meter:** | 4/4 |
| **Sequence:** | A. Tynoks, hop-step step, prytup |
| | B. Reel BK, toe–heel, cross and kick |
| | C. Holubchuk with Ptr, bihunets |
| **Basic Steps:** | Tynok, prytup, holubchuk, bihunets, reel |

## Dance Description

*Meas*

1–4     Introduction (Cts 1–16)

**Part I**

1–2     4 Tynoks (Cts 1–8)

3     Hop L FT (Ct 1), step R to R (Ct &), step L (closing to R) (Ct 2), prytup (Cts 3 & 4)

4     Turning to L, step L (Ct 5), step R (Ct 6), face Ptr and prytup (Cts 7 & 8)

**Part II**

1     Reel BK 4 times, beginning with R FT (Cts 1–4)

2     Run BK with 3 steps R, L, R (Cts 5 & 6), step L turn 1/4 to L (Ct 7), stamp R still facing 1/4 to L (Ct 8)

3     Turn to face Ptr and travel FWD, stepping R, L (Cts 1 &), drop R and extend L FT to side with FT pointed (Ct 2), repeat opposite FT (Cts 3 & 4)

4     Place R toe to side on floor (turned in) (Ct 5), replace with R HL on floor (FT turned out) (Ct 6), R FT crosses L ankle (passé) (Ct 7). Extend R FT to side (Ct 8)

### Part III

1-2 Holubchuk with Ptr, R sides together (Cts 1-8). End to both face LOD in varsouvienne position on counts 7, 8

3-4 Bihunets LOD (varsouvienne position). On Cts, 7, 8, let go of hands and face each other (Cts 1-8)

5-8 Repeat Meas 1-4 (Cts 1-16)

**Repeat the entire dance 2 more times from the beginning**

## Additional Information

The tynok is very lifted and executed as an "up, up, down" movement. The styling of the entire dance is proud and controlled, with exact placement of arms and feet. During the holubchuk, the bihunets step is used.

## Sweden  Mona's Festvals

This waltz was introduced in the United States by Yvonne Holland who learned the dance in Sweden. It was choreographed by Ann-Louise Jönsson. This is a fun mixer to be used at any social gathering.

| | |
|---|---|
| **Pronunciation:** | MOH-nahs FEHST-vahls |
| **Formation:** | Single circle facing center, Ptrs with W on R side of M |
| **Position:** | No contact, hands at sides |
| **Meter:** | 3/4 |
| **Sequence:** | A. Balancé, progressive turn |
| | B. Chain and arch |
| | C. Couples Waltz |
| **Basic Step:** | Waltz |

## Dance Description

Meas

### Part I

1-2 2 Waltz Balancés, 1 FWD and 1 BK (M begin L, W begin R) (Cts 1-2)

3-4 2 Waltz steps progressing around the circle. (W turn R and progress CCW on inside of circle into place vacated by W to the R. M turn L and progress CW on outside of circle into place vacated by M to the L.)

5-20 Repeat the above sequence 4 more times.

### Part II

1      Men facing CCW, Women CW with new Partner, give R hands with 1 waltz step to pull by

2      Giving L to the next, pull by (1 waltz step)

3      Giving R to the third, turn W 1 full turn under R arm turning her to her L (1 waltz step in place)

4      Retaining R hands, 1 waltz step away from each other, extending arms

5-8     Repeat Meas 1-4

### Part III

1-8     Couples Waltz in closed position turning CW, moving CCW around circle

1-8     Repeat Part II

9-16    Repeat Part III

### Repeat the entire dance from the beginning

1-16    *During the conclusion of the dance, couples continue waltzing anywhere on the floor until music ends.

## Serbia ◆ Orijent

This dance was introduced in the United States in the 1960s by Richard Crum. The name of the dance most likely came from the Orient Express, a train that passed through Serbia traveling from Paris, France, to Istanbul, Turkey. It was one of the most popular, "kolos" in the "Sumadija" area of Serbia, being danced by students and workers at various social gatherings.

| | |
|---|---|
| **Pronunciation:** | OHR-ee-ehnt |
| **Formation:** | Lines |
| **Position:** | Hans held in low "V" |
| **Meter:** | 4/4 |
| **Sequence:** | A. Touch grapevine |
| | B. Side shake, walk FWD & BK |
| | C. Small leaps FWD & BK |
| **Basic Steps:** | Walk, grapevine, shake leg, leap |

# Dance Description

*Meas*

None    Introduction

### *Part I*

1    While touching L (XIF), bounce twice on R, step L (Cts 1 & 2)

Step R to R, step L (XIB), step R to R moving LOD (Cts 3 & 4)

2-8    Repeat 7 more times (Cts 1-4)

### *Part II*

1    Step L to L, step R to center, step L to center, lift up on L FT, raising R knee slightly in front (Cts 1-4)

2    Step R BK, step L BK, step R BK, lift on R and double shake L FT to L (Cts 5, 6, 7, & 8)

3-8    Repeat Meas 1-2, 3 more times (Cts 1-8)

### *Part III*

1    Small leap L DIAG L FWD, closing R to L (S) (Ct 1)

Small leap R DIAG R FWD, closing L to R (S) (Ct 2)
L, R, L (q, q, S) (repeat same styling in feet as Cts 1 & 2) (Cts 3 & 4)

2    Reverse Meas 1 (Cts 5-8)

3-4    Repeat Meas 1-2 backing out from center (Cts 1-8)

5-8    Repeat Meas 1-4 (Cts 1-16)

**Repeat the entire dance from the beginning**

## Scotland/England  Oslo Waltz

This is a waltz mixer danced both in England and Scotland. The dance was introduced to the United States by Michael and Mary Ann Herman. It is usually danced at the end of an evening to say farewell and is known as the "good night" waltz.

| | |
|---|---|
| **Pronunciation:** | OHS–lo Waltz |
| **Formation:** | Single Circle facing center, Ptrs with W on R side of M |
| **Position:** | Hands held in low "V" |
| **Meter:** | 3/4 |
| **Sequence:** | A. Balancé and progress |
| | B. Counter balancé, turn |
| | C. Draw and dip |
| | D. Waltz turn |
| **Basic Steps:** | Balancé, draw step, waltz |

## Dance Description

*Meas*

1–8    Introduction

### Part I

1    Waltz balancé FWD, M start L, W start R (arms swing FWD slightly) (Cts 1–3)

2    Waltz balancé BK (arms swing BK) (Cts 1–3)

3–4    M balancés L in place, balancé R in place while leading W on L across in front to his R side, changing L to R hand hold. W makes one complete turn, not arch, CW while doing two waltz steps (Cts 1–6)

5–12    All rejoin hands and repeat Meas 1–4 three more times. On Meas 4 M faces LOD and receives new Ptr from his R. W faces RLOD. Both take closed position on last Ct (Cts 1–12)

### Part II

1    Couples waltz balancé sideways toward center, M start L, W start R (Cts 1–3)

2    Waltz balancé away from center (Cts 1–3)

3    Turn individually once around, M to L, W to R in one waltz step (Cts 1–3)

4    Do 2 steps in place and hold count 3 (Cts 1–3)

1–4    Repeat Part II, beginning away from center, M start R, W start L. On individual turns, this time M turn CW, W turn CCW, both moving slightly away from center (Cts 1–12)

### Part III

1   Take elongated arms and M step L (W step R) toward center (Cts 1, 2). M draw R to L, W draw L to R (Ct 3)

2   M step L to L (Ct 1, 2), point R FT to R side (Ct 3), arms dip toward pointed FT. W reverses pattern

3-4   Reverse and repeat. On last draw step, couple takes closed dance position (Cts 1-6)

### Part IV

1-4   In closed dance position, take 4 CW turning waltz steps while progressing LOD, opening up to end in a single circle facing center on last C (Cts 1-12)

**All join hands and repeat the entire dance from the beginning**

---

## Scotland  ◆  Road to the Isles

The melody of "Road to the Isles," called "Bens of Jura," is a favorite marching song of Scottish pipe bands. The dance is of a later period, but is similar to the Scottish Polais Glide and to the Douglas Schottische.

| | |
|---|---|
| **Formation:** | Double Circle, Ptrs facing LOD *Mass* |
| **Position:** | Varsouvienne |
| **Meter:** | 2/4 |
| **Sequence:** | A. Point, grapevine |
| | B. Schottische and turn |
| **Basic Steps:** | Point, grapevine, schottische |

## Dance Description

*Meas*

1-12   Introduction (Cts 1-24)

### Part I

1   Point and touch L to FWD L DIAG (Cts 1-2)

2   Step L (XIB), step R (Cts 3-4)

3   Step L (XIF) (Cts 5-6)

4–6     Reverse and Repeat Meas 1–3 (Cts 7–8, 1–4)

7       Touch L FWD (Cts 5–6)

8       Touch L BK (Cts 7–8)

**Part II**

1–2     Schottische FWD, starting L, hop L (Cts 1–4)

3–4     Schottische FWD on R, hop R, turn R 1/2 to face RLOD (do not release hand) (Cts 5–8)

5–6     Schottische FWD on L, hop L, turn L 1/2 turn to face LOD (do not release hands) (Cts 1–4)

7–8     Step in place R, L, R (Cts 5–7, hold Ct 8)

**Repeat entire dance from the beginning**

---

# Romania  Rustemul

"Rustemul" is from Southern Romania, the region of Muntenia. It was learned by Mihai David between 1963–65 while dancing with the Romanian State Folk Dance Ensemble.

| | |
|---|---|
| **Pronunciation:** | ROO–steh–mool |
| **Formation:** | Lines |
| **Position:** | Hands held in low "V" |
| **Meter:** | 2/4 (The dance brief is notated in Cts of 4) |
| **Sequence:** | A. Basic step in place |
| | B. Basic step variation traveling FWD and BK |
| | C. Basic step variation traveling DIAG FWD and BK |
| **Basic Step:** | Step, slide, hop |

## Dance Description

*Meas*

1–4     Introduction

**Part I**

1       On upbeat, lift L HL raising bent R knee FWD (Ct &)

        Step R to R with bent knee, arms swinging BK (Ct 1)

XLIF of R, stepping flat onto L FT (Ct &)

Step R BK to place, arms swinging FWD (Ct 2)

2      **Repeat and Reverse Meas 1** (Cts & 3, & 4)

3      **Repeat and Reverse Meas 2 again** (Cts & 1, & 2)

4      Step L flat to L (Ct &)

Step R in place, arms swing BK (Ct 3)

XLIF of R, stepping flat onto L FT (Ct &)

Step R BK to place, arms swing FWD (Ct 4)

5-8    **Repeat and Reverse Meas 1-4** (Cts 1-8)

*Part II*

1-2    **Repeat and Reverse Part I Meas 1-2** (Cts 1-4)

3      Step R, turn body to face R DIAG (the arms are held FWD until the end of Meas 6, and then they resume swinging) (Ct &)

Step FWL L (traveling FWD not DIAG) (Ct 1)

Step R FT FWD beside L FT (Ct &)

Step L FT FWD (Ct 2)

4      **Repeat and Reverse Meas 3 Cts 1-2** (Cts 3-4)

5      Step L FT (XIF of R FT) turn body to face R DIAG (Ct 1)

Step BK with R FT (Ct 2)

Step BK with L FT beside R FT (Ct &)

6      Step BK with R FT (Ct 3)

Step BK with L FT beside R FT (Ct &)

Step BK with R FT (Ct 4)

| | |
|---|---|
| 7-8 | **Repeat and Reverse Part I Meas 1-2** (Cts & 1-4) |
| 1-8 | **Repeat and Reverse all of Part II** (Cts 1-16) |

*Part III*

| | |
|---|---|
| 1 | Turn to face R DIAG, hop on L, bringing R knee slightly up (Ct &) |
| | Step R FWD (Ct 1) |
| 2 | **Repeat and reverse, continuing to travel FWD on the R DIAG** (Cts & 2, & 3, & 4) |
| 3-4 | **Repeat Part I Meas 1-2** (Cts 1-4) |
| 5-6 | **Repeat Part III Meas 1-2 Cts 1-3, but travel backward** (on Cts "&4," step L, then step R) (Cts 1-4) |
| 5-7 | **Repeat and Reverse Part III facing L DIAG** (Cts 1-2) |
| | **\*To complete: Repeat Part I, Part II, Part I, Part III** |

**Additional Information**

The arms swing BK and FWD continuously throughout the entire dance. The styling is earthy and flat-footed. The feet do not lift very high off the ground. Sequence Pattern is: I, II, II, I, II, I, III

## United States ◆ Salty Dog Rag

"Salty Dog Rag" is a popular American dance that is of a high energy level. This dance can be used in parade routes and is based on a schottische rhythm.

| | | |
|---|---|---|
| **Formation:** | Double Circle, Ptrs facing LOD | |
| **Position:** | Promenade | |
| **Meter:** | 4/4 | |
| **Sequence:** | A. Schottische FWD | |
| | B. Cross over and turns | |
| | C. Heel step and schottische | |
| **Basic** | Step: Schottische, HL step | |

# Dance Description

*Meas*

1-4       Introduction (Cts 1-16)

**Part I**

1-2       1 schottische moving DIAG R FWD (M R, W R), then 1 schottische DIAG L FWD (Cts 1-8)

3-4       Four step-hops moving FWD LOD, R, L, R, L (Cts 1-8)

1-4       **Repeat Meas 1-4** (Cts 1-16)

**Part II**

1-2       Drop R hands retaining L-hand hold, change places with one grapevine style schottische step, W passing in front of M, with W ending R LOD. Using slight resistance against L hand of Ptr to start turn, turn L making 1 full individual turn, returning to original place using one schottische step (W still ends facing RLOD) (Cts 1-8)

3-4       Grasp R hands in "W" position. Do 4 step-hops FWD to make a complete circle CW, bringing W BK to outside of circle (Cts 1-8)

1-4       **Repeat Meas 1-4 grasping L hands for initial cross over** (Cts 1-16)

**Part III**

1-2       Place R HL FWD, step on R FT in place, place L HL FWD, step on L FT, place feet in pigeon-toe position, bring HLs together, stamp R, stamp L (Cts 1-8)

3-4       Four step-hops FWD, R, L, R, L (Cts 1-8)

1-4       **Repeat Meas 1-4** (Cts 1-16)

          **Repeat the entire dance from the beginning**

## Additional Information

### Advanced version for Part III:

1-2       Holding R hands, W slightly in front of M, W make R pivot turn (complete turn on R FT, step FWD on L). Repeat 2 times then stamp R, L. M step R, brush L FWD, step L, brush R FWD, step R, brush L FWD, stamp L, touch R with no weight on R FT (Cts 1-8)

3-4       Take promenade position and move CCW with 4 step-hops, starting R FT (Cts 9-16)

5-8       **Repeat Meas 1-4** (Cts 1-16)

# Germany  Sauerlaender Quadrille

"Sauerlaender Quadrille" comes from the village of Neheim-Husten where the basic step pattern (Neheimer) derives its name. It was introduced by Paul and Gretel Dunsing in the 1950s.

| | |
|---|---|
| **Pronunciation:** | ZOW-her-lehnd-er QUAH-dreel |
| **Formation:** | Four couple square (numbered CCW, 1-3-2-4), couple 1 with backs to music, W on M's R |
| **Arm Position:** | No contact, arms held down by sides |
| **Meter:** | 4/4 |
| **Sequence:** | A. Peek-a-boo |
| | B. To the right |
| | C. Crossover |
| | D. R-hand star |
| | E. Grand Slam |
| **Basic Step:** | Neheimer: (The standing FT has a slight bounce each Ct) Touch R toe (knee and toe turned in), touch R toe (knee and toe turned out), replace R toe with R heel (still turned out), touch toe (XIF of L FT), step side with R FT, XIB with L FT, bounce 2 times with feet together. Reverse FTWK and only bounce once. (Each movement gets one count) |

**2**

**4**          **3**

**1**

**HEAD OF HALL**

## Dance Description

*Meas*

1-4        Introduction (Cts 1-16)

**Part 1** (Peek-a-boo)

1-2        M 1 moves L, W 2 moves R, with first half of Neheimer stop (Peek-a-boo around couple 4) (Cts 1-8)

3-4        2nd half of Neheimer step to return home (Cts 1-8)

5-8        M2 and W1 peek-a-boo around couple 3 and BK (Cts 1-16)

9-12      M3 and W4 peek-a-boo around couple 1 and BK (Cts 1-16)

13-16    M4 and W3 peek-a-boo around couple 2 and BK (Cts 1-16)

### Part II (To-the-right)

1-2    Couple 1 faces and moves to own R with first half of Neheimer (M and W starting on R FT) (Cts 1-8)

3-4    2nd half of Neheimer step to return home (Cts 9-16)

5-16    All couples perform action in their turn (couples 2, 3, then 4) (Cts 1-48)

### Part III (Crossover)

1-4    Couples 1 & 2 move toward each other with first half of Neheimer. Passing R shoulders, meet in straight line in the center of the square (M on outside) to do double bounce, then progress to opposite side with second half of Neheimer step (when traveling FWD, the Neheimer step should be executed as follows: toe, toe, HL, toe, FWD, FWD, bounce, bounce). On last bounce, turn toward Ptr to face center of set (Cts 1-16)

5-8    Couples 3 & 4 crossover (Cts 1-16)

9-12    Couples 1 & 2 return home (W on outside) (Cts 1-16)

13-16    Couples 3 & 4 return home (W on outside) (Cts 1-16)

### Part IV (R-hand star)

1-4    Couple 1 facing and beginning L, join R hands and move CW with one Neheimer to circle and return home using R FT on the second Neheimer step (Cts 1-16)

5-16    All couples perform action in their turn (couples 2, 3, then 4) (Cts 1-48)

### Part V (Grand Slam)

1-4    Couples 1 & 2 crossover, couples 3 & 4 peek-a-boo (Cts 1-16)

5-8    Couples 1 & 2 peek-a-boo, couples 3 & 4 crossover (Cts 1-16)

9-16    **Repeat Meas 1-8, couples returning home** (Cts 1-32)

1-4    All couples to-the-right (Cts 1-16)

5-8    All couples R-hand star (Cts 1-16)

1-8    **Repeat all couples-to-the-right and all couples R-hand star** (Cts 1-32)

## Additional Information

A dancer faces the center of the square without moving until it is his or her turn to dance. The dance is light and jovial and has an element of surprise. The dancer should stand tall with arms held straight down at side of body.

## Hungary  Somogyi Karikázó

"Somogyi Karikázó" is a circle dance belonging to the "old layer" of Hungarian folk dance. It displays many traditional and commonly used Hungarian steps. Originally, this was a women's dance from the Somogyi district in Southern Hungary. Recreationally, men have been included in the United States, but only participate outside the women's circle.

| | |
|---|---|
| **Pronunciation:** | SHOH-moh-djee KAH-ree-kah-zoh |
| **Formation:** | W form a single circle, M form a semi circle wrapping around the outside of the W's circle |
| **Position:** | W front basket hold, R arm over L. M shoulder to shoulder in "T" hold |
| **Meter:** | 6/8 |
| **Sequence:** | Intro. Swaying (12 cts)<br>A. Lepo, individual R turn (6)<br>B. Czardas steps (slow, fast) (4 slow, 4 fast)<br>C. Cifra variation #1 (6)<br>D. Cifra variation #2 (6)<br>E. Closed rida to L (12)<br>Repeat C, D, and E |
| **Basic Steps:** | Lepo, czardas, cifra, rida, click HLs together |

## Dance Description

*Meas*

None    Introduction

1-6    Begin swaying by shifting weight to R, then to L (a total of 12 times) (Cts 1-36)

**Part I** (Lepo)

1    Step R XIF of L, step L DIAG BK to L (Cts 1-2)

**Repeat Cts 1-2 twice** (Cts 3-6)

2    Making a complete individual R turn, walk R, L, R, L. R arm does "port de bras" (port de bras: bring R arm across body to left side extending the R arm up and over to the R side, making an arc figure overhead) (Cts 7-10)

Two closed rida to L (dancers rejoin the front basket hold) (Cts 11-12)

3-12    **Repeat Meas 1-2, five times** (Cts 1-60)

***Part II*** (Czardas)

1    Step R to R (Cts 1–2)

Close L to R (Cts 3–4)

Step R to R (Cts 5–6)

2    Touch L to R (Cts 7–8)

Step L to L (Cts 9–10)

Touch R to L (Cts 11–12)

3–8    **Repeat Meas 1, three more times** (Cts 1–36)

9–10    **Repeat Meas 1–2, four more times, double time** (Cts 1–48)

***Part III*** (Cifra Variation #1)

1    Small leap FWD onto R (almost in place) (Ct 1)

Step L next to R (Ct &)

Step R in place (Ct 2)

Large leap L DIAG BK onto L (Ct 3)

Step R next to L (Ct &)

Step L in place (Ct 4)

2–6    **Repeat Meas 1, five more times** (Cts 1–20)

***Part IV*** (Cifra Variation #2)

1    Small leap FWD onto R (almost in place), L behind R ankle (Ct 1)

Hold (Ct 2)

Large leap L DIAG BK onto L (Ct 3)

Step R next to L (Ct &)

Step L in place (Ct 4)

2–6    **Repeat Meas 1, five more times** (Cts 1–20)

**Part V** (Rida)

1       Step R FWD XIF of L (Ct 1)

        Step L to L (Ct &)

2-12    **Repeat Meas 1, eleven times** (Cts 2-12)

        **Repeat Part III**

        **Repeat Part IV**

        **Repeat Part V** (Only do the Rida step ten times and finish the dance with a run (R), run (L), click R FT to L FT

## Additional Information

This dance moves to the L continuously throughout the entire dance, except for czardas. The movement is smooth and lyrical in nature. Cifra means "fancy step," and Rida means "to run." Sequence of the dance is as follows: Intro, A, B, B, C, D, E, C, D, E.

| Israel |  | Stav Lavan |
|---|---|---|

"Stav Lavan" means "White Autumn." Ya'akov Eden taught this dance at an Idyllwild Folk Dance Camp. This dance is a slower type of Israeli dance in a 3/4 rhythm.

| | |
|---|---|
| **Pronunciation:** | STAHV lah-VAHN |
| **Formation:** | Double circle, Ptrs facing LOD |
| **Position:** | Hands held at shoulder height in "W." Inside of hands face out, touching the inside of hands of Ptrs |
| **Meter:** | 3/4 |
| **Sequence:** | A. Step brush |
| | B. Waltz, crossover and back |
| | C. Waltz box, yemenite with Ptr, wheel |
| **Basic Steps:** | Walk, brush, waltz, yemenite |

# Dance Description

### (M's steps are described, W do opposite)

*Meas*

1-8    Introduction (Cts 1-24)

### *Part I*

1    Step L FWD, brush R FWD, step R FWD (Cts 1-3)

2    Step L FWD, brush R FWD, step R to R while making 1/4 turn R to face W (Cts 4-6)

3    Cross L over R, step R in place, close L to R and make 1/4 turn L to face LOD (Cts 1-3)

4    Step R FWD, step L BK, close R to L (Cts 4-6)

5-8    **Repeat Meas 1-4** (Cts 1-12)

### *Part II*

1    Waltz FWD L, R, L (Cts 1-3)

2    Waltz BK R, L, R (Cts 4-6)

3    Cross L over R with bent knee while passing behind W, step R to R, step L in place (Cts 1-3)

4    **Repeat Meas 3 with opposite Ftwk and direction** (Cts 4-6)

5-8    **Repeat Meas 1-4** (Cts 1-12)

### *Part III*

1    Waltz FWD L, R, L (Cts 1-3)

2    Waltz to R while passing in front of W, R, L, R (Cts 4-6)

3    Waltz BK L, R, L (Cts 1-3)

4    Join inside hands and step R to R, step L to R, then cross R over L while passing behind W and raising joined hands for W to pass under (this is a side yemenite step) (Cts 4-6)

5    **Repeat Meas 4 with opposite Ftwk and direction** (Cts 1-3)

6    **Repeat Meas 4. End by joining free hands in cuddle position** (Cts 4-6)

7-8    2 waltz steps or 6 walking steps FWD starting L, while making one full circle CW (Cts 1-6)

9-16    **Repeat Meas 1-8, releasing cuddle position to begin again** (Cts 1-12)

**Repeat the entire dance from the beginning**

## Additional Information

The dancer's arms should be held loosely down by sides on Part II and Part III, meas 1-3. The movement is smooth and lyrical, using the waltz rhythm.

## Ireland  Sweets of May

Sean and Una O'Farrell introduced this dance to the United States. It comes from the Northern part of Ireland and exemplifies many typical Irish steps. "Sweets of May" means "the pleasure or joys of May."

| | |
|---|---|
| **Formation:** | Square, four couples (numbered CCW 1-2-3-4). Couple 1 with backs to music, W on M's R. |
| **Position:** | Hands held at shoulder height in "W," standing close together |
| **Meter:** | 4/4 |
| **Sequence:** | A. Seven's and Three's, chorus |
| | B. Promenade, chorus |
| | C. Arches, chorus |
| | D. Thread the needle |
| | E. Seven's and Three's |
| **Basic Steps:** | Seven's and Three's, skip-change-of-step |

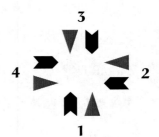

**HEAD OF HALL**

Seven's and Three's: To count the Seven's, even numbers are on "&." For example, what is normally counted "1 & 2 & 3 & 4" would be counted as "1 2 3 4 5 6 7." When moving L, the R leg is lifted and placed behind the L on 1, L steps to L on 2, R steps behind L on 3, etc. To move R, footwork is reversed, starting with L behind R, R to R, etc. Three's are a simple hop-step-close-step with the first step reeling behind and in place, counted "hop 1 2 3." Three's are always done twice (e.g., 7, 3, 3, 7, 3, 3, etc.)

## Dance Description

*Meas*

1-4     Introduction (Cts 1-16)

**Part 1** (Seven's and Three's in a **circle**)

1-2     Moving L, stepping with R FT behind L, do one Seven's and Three's step (Cts 1-8)

3-4     Moving R do another Seven's and Three's step (Cts 1-8)

5-6     Move R with Seven's and Three's step. Weight is on L FT at end of last Three's push off on R toe (Ct &), step L behind R to start Seven's and Three's (Cts 1-8)

7-8     Move L BK to starting place with Seven's and Three's (Cts 1-8)

**Chorus** (Use skip-change-of-step when moving. When standing in place, dance Three's)

| | |
|---|---|
| 1 | Couples 1 & 3 exchange places with 2 skip-change-of-steps. Ptrs hold inside hands. M will pass L shoulders in the center of square as they cross over (Cts 1-4) |
| 2 | Couples 1 & 3 turn in toward Ptr to reverse directions as couples 2 & 4 exchange places with 2 skip-change-of-steps (Cts 5-8) |
| 3 | Couples 1 & 3 return home, W pass L shoulders in the center of square. Couples 2 & 4 turn toward Ptr to reverse directions (Cts 1-4) |
| 4 | Couples 2 & 4 return home. Couples 1 & 3 turn in toward Ptr and end facing center of set (Cts 5-8) |
| 5 | Couples 1 & 3 RWD with 2 skip-change-of-steps and bow to opposites (Cts 1-4) |
| 6 | Couples 2 & 4 FWD with 2 skip-change-of-steps and bow to opposites while couples 1 & 3 move BK with 2 skip-change-of-steps (Cts 5-8) |
| 7-8 | Couples 1 & 3 repeat action of Meas 5 as couples 2 & 4 move BK. Couples 2 & 4 do Three's in place while couples 1 & 3 BK out (Cts 1-8) |
| 9-10 | All face center. Slap thighs twice, own hands twice, **Repeat** (Cts 1-8) |
| 11-12 | Change places with Ptr, M passing behind W, with Seven's and Three's step (M step L behind R to start Seven's and Three's, W step R behind L) (Cts 1-8) |
| 13-16 | Repeat Meas 9-12 and change places with Ptr. This time M passes in front of W (Cts 1-16) |

### *Part II* (Promenade)

| | |
|---|---|
| 1-4 | Ptrs facing CCW, inside hands "W" position, promenade around with 7 skip-change-of-steps. On 8 turn in toward Ptr to RLOD (Cts 1-16) |
| 5-8 | Repeat promenade CW, ending in starting place, facing center on Meas 8 (Cts 1-16) |

**Repeat Chorus**

### *Part III* (Arches)

| | |
|---|---|
| 1 | Couples 1 & 3 face couple on their R (1 faces 2, 3 faces 4). Head couples (1 & 3) arch over side couples for 2 skip-change-of-steps, changing places (Cts 1-4) |
| 2 | Turn in toward Ptr for 2 skip-change-of-steps to reverse directions (Cts 5-8) |
| 3 | Couples 2 & 4 arch with couples 1 & 3 going under the arch, BK to home (Cts 1-4) |
| 4 | Turn in toward Ptr for 2 skip-change-of-steps to end facing center (Cts 5-8) |
| 5-8 | Repeat arches, couples 1 & 3 facing couple on their L. Head couples always arch first (Cts 1-16) |

**Repeat Chorus**

### Part IV (Thread the Needle)

1–4     Join hands in circle with break between M1 and W4. Couple 1 arches and using 8 skip-change-of-steps, W4 leads line under arch, around in circle CCW, and home with M1 turning under own arm on last count (do not let go of hands) (Cts 1–16)

5–8     Couple 4 arches and M1 leads line CW under arch and home with W4 turning under own arm on last count (Cts 1–16)

### Repeat Part I, Seven's and Three's in a circle

Bow or curtsey to own Ptr on last note of music.

## Additional Information

The promenade position has inside hands joined in a tight "W" with partners' forearms touching and the other hand is held down by side. The dancers should stand tall and be very lifted in the upper body. There is little or no movement in the torso. The style should be stiff and the leg should execute all movement.

# Greece ◆ Syrtos

The "Syrtos" goes back to the sixteenth century when Turkey conquered Greece. The dance is still done in Greek cafes, clubs, and at times of celebration, such as weddings. In the past, men and women danced in separate lines, now they intermix with the leader on the right end of the line. A handkerchief, used to signal a change in step pattern, is held between the leader and the second dancer.

| | | |
|---|---|---|
| **Pronunciation:** | sear-TOH |  |
| **Formation:** | Open circle | |
| **Position:** | Hands held shoulder height in "W" (Leader on R) | |
| **Meter:** | 2/4 | |
| **Sequence:** | Chorus, Part I, Chorus, Part II, Chorus, Part III | |
| **Basic Steps:** | Grapevine, lift, stomp, touch | |

# Dance Description

*Meas*

Introduction

Chorus (Step cross)

1    Face LOD and step on R to R FT (S), step L FT XIB of R (q), step to R on R FT (q) (Cts 1–4)

2    Step L FT slightly XIF of R FT (S), step R FT to R (q), step L FT slightly XIF of R FT (q) (Cts 1–4)

***Part I*** (Step lift)

3–4    Face center, step to R on R FT, lift L FT slightly off the floor and XIF of R, step to L on L FT, lift R FT slightly off the floor and XIF of L (Cts 1–8)

5–6    **Repeat Chorus** (Cts 1–8)

***Part II*** (Step stomp)

7–8    Facing center, step to R on R FT, bending R slightly, stomp the L FT next to the R FT, step to the L on the L FT, bending L leg slightly, stomp R FT next to L FT (Cts 1–8)

9–10    **Repeat Chorus** (Cts 1–8)

***Part III*** (Step touch)

11–12    Facing center, step to R on R FT, touch the ball of the L FT slightly FWD by R FT, step to L on L FT, touch the ball of the R FT slightly FWD by L FT (Cts 1–8)

## Additional Information

There are many variations in this dance during the verses. If the leader wants to change to the end of the line, he does so during the chorus and a new leader then takes his place. The knees are always flexed with an ease and lightness in the steps. The rhythm is slow (Ct 1 &), quick (Ct 2), quick (Ct &)

# Japan  Tokyo Dontaku

This dance was learned from a Japanese community in Honolulu by Madelynne Greene. She introduced the dance to the United States in 1961. "Tokyo Dontaku" translates to mean "Tokyo day-off." In mid-July, an annual three day Buddhist feast called "O-Bon" is held in Japan. The purpose of the feast is "to welcome home for a visit the spirits of departed ancestors."

| | |
|---|---|
| **Pronunciation:** | TOE-kyoh-dohn-TAH-koo |
| **Formation:** | Single circle facing LOD |
| **Position:** | No contact |
| **Meter:** | 4/4 |
| **Sequence:** | A. Walk FWD, FWD and BK |
| | B. Slow and quick walks |
| | C. Turn and hold |
| | D. Turn with walks |
| **Basic Steps:** | Walk |

## Dance Description

*Meas*

1-4    Introduction (Cts 1–16)

### Part I

1    Walk R (Cts 1, 2), walk L (Cts 3, 4), clap low in front with straight arms on (Cts 1 & 3)

2    Step FWD R, swinging arms low to the side (Ct 5), step BK L, swing arms in (Ct &), step BK R beside L and clap (Ct 6), hold (Cts 7, 8) *rhythm is slow, slow, quick-quick, slow

### Part II

1    Walk L, both arms swinging by L side (Cts 1, 2), walk R, arms swinging by R side (Cts 3, 4)

2    3 quick walks, L, R, L (Cts 5 & 6). On Ct 5, R arm extends straight FWD, R hand flexed with palm facing FWD, while L elbow is bent and held forward, L hand flexed with palm facing BK. Hold (Cts 7, 8)

### Part III

1    Step with R FT, keeping L behind a 1/2 turn to R to face outside circle, both arms extending to each side and lifting above head, fingers pointed toward body and palms down (Cts 1, 2, 3). Bring L knee up and flex the hands above the head (Ct 4)

2    **Repeat and reverse Meas 1, ending to face center of circle** (Cts 5–8)

### Part IV

1   Walk R, L, R, brush L FT FWD, turning _ to R to end facing outside of circle R arm is in front of body, elbow bent, palm facing BK, R forearm is a vertical, L elbow is bent, L arm is held horizontal in front of body, palm down, fingers touching R elbow) (Cts 1–4)

2   **Repeat and reverse Meas 1** (except hold Ct 8 instead of brushing R FT FWD), ending to face center of circle (Cts 5–8)

**Repeat the entire dance from the beginning**

## Additional Information

Knees are together and slightly bent with the toes pointed inward. The men dance more vigorously than the women.

# Scotland ◆ Trip to Bavaria

This reel is a country dance choreographed by a Scottish County Dance exhibition team in about 1969 while touring Bavaria. It was presented by C. Stewart Smith to the San Diego University Folk Dance Conference in 1974.

| | |
|---|---|
| **Formation** | 4 couples in longways set, M to L of head of hall |
| **Position:** | No contact, hands held down by side |
| **Meter:** | 2/4 |
| **Sequence:** | A. R-hand star and chain across |
| | B. Set & Cross |
| **Basic Step:** | The strathspey is used throughout the dance unless otherwise stated. Begin strathspey stepping on R foot. |

```
4 ▶        ◀ 4
3 ▶        ◀ 3
2 ▶        ◀ 2
1 ▶        ◀ 1
```

**HEAD OF HALL**

## Dance Description

*Meas*

1–4   Introduction (Cts 1–8)

### Part I

1–2   Couples 1 & 4 (on the two ends) join R hands and pass R shoulders, exchanging places. Couples 2 & 3 (in the center) form R-hand star and move half-way around star CW (Cts 1–4)

3–4   Couples 1 & 4 trade to the center with couples 2 & 3, who trade out of the center. All give L hands in passing (Cts 1–4)

5-6      Couples 2 & 3 chain across, joining R hands, and couples 1 & 4 do R-hand star half-way around, CW (Cts 1–4)

7-8      Couples 2 & 3 trade to the center with couples 1 & 4, who trade out of the center. All give L hands in passing (Cts 1–4)

9-16     **Repeat Meas 1-8 ending in original position** (Cts 1-16)

         *Part II*

1-2      Couples 1 & 2 face each other DIAG across and do a strathspey setting step to opposite (2 setting steps) (Cts 1–4)

3-4      Couple 1 crosses over and moves down to couples 2's position. (The W always crosses first while the M crosses behind his Ptr.) Couple 2 moves up the set with 2 strathspey steps to couples 1's position (Cts 1–4)

5-8      Couples 2 & 3 repeat action of Meas 1-4 with couples 1 continuing down the set and couple 3 moving up the set one position (Cts 1–4)

9-12     Couples 1 & 4 repeat action of Meas 1-4 with couple 1 continuing down the set and couple 4 moving up the set one position (Cts 1–4)

13-14    Couples 2, 3, & 4 join hands down the line and move FWD with 2 strathspey and slight acknowledgment to meet opposite line. Couple 1 takes two-hand position and change places (Cts 1–4)

15-16    All couples hold hands and move BK with 2 strathspey to original set, all couples having progressed one position (Cts 1–4)

         **Repeat the entire dance from the beginning 3 more times with all couples ending in original position**

## Additional Information

### *Part I Formations:*

| Meas 1-2 | Meas 3-4 | Meas 5-6 | Meas 7-8 |
|---|---|---|---|
| M4 W 4 | M2 W2 | W2 M2 | W1 M1 |
| M2 W 2 | M4 W4 | W1 M1 | W2 M2 |
| M3 W3 | M1 W1 | W4 M4 | W3 M3 |
| M1 W1 | M3 W3 | W3 M3 | W4 M4 |

### *Part II Formations:*

| Meas 3-4 | Meas 7-8 | Meas 11-12 | Meas 13-14 |
|---|---|---|---|
| W4 M4 | W4 M4 | M1 W1 | W1 M1 |
| W3 M3 | W1 M1 | W4 M4 | W4 M4 |
| M1 W1 | W3 M3 | W3 M3 | W3 M3 |
| W2 M2 | W2 M2 | W2 M2 | W2 M2 |

## Israel  Uvneh Yerushalayim

"Uvneh Yerushalayim's" translates to "Jerusalem."

| | |
|---|---|
| **Pronunciation:** | OOV-neh YEHR-oo-shah-LI-ihm |
| **Formation:** | Single circle, facing center |
| **Position:** | Hands held in low "V" |
| **Meter:** | 4/4 |
| **Sequence:** | A. Pas de basques, grapevines |
| | B. Grapevine, individual circle |
| **Basic Steps:** | Pas de basques, grapevines |

## Dance Description

*Meas*

1-6    Introduction (Cts 1-24)

**Part 1**

1-2    4 pas de basques R, L, R, L (Cts 1-8)

3    Step R to R, step L to R (XIB), step R to R, small hop on R while holding L FT up (Cts 1-4)

4    Step with L (XIF) of R, step R to R, step with L (XIF) of R, hop on L (Cts 5-8)

5    **Repeat Meas 3** (Cts 1-4)

6    Step L to L, step R to L (XIB), step L to L, small hop on L (Cts 5-8)

7    Small runs FWD toward center of circle R, L, R, small hop on R (while traveling FWD raise both arms) (Cts 1-4)

8    Small runs BK L, R, L, small hop on L (while traveling BK lower both arms) (Cts 5-8)

9-16    **Repeat Meas 1-8** (Cts 1-32)

### Part II

1      Step R to R with flat FT, close L to R using flat FT (change arms to "W" position and pump them up and down while doing the step) (Cts 1–2)

2      Repeat 3 more times (Cts 3–8)

3      Step R FT to L (XIF), step L to L, step R FT to L (XIB), step L to L (rock FWD and BK with upper body) (Cts 1–4)

4      Repeat Meas 3 one more time (Cts 5–8)

5      Repeat Meas 7 of Part I (Cts 1–4)

6      Repeat Meas 8 of Part I (Cts 5–8)

7–8      Turning R, walk in small individual circle, using Ftwk from Meas 1–2. Raise both arms above head and turn palms in and out with each step (Cts 1–8)

9–16      Repeat Meas 1–8 one more time (Cts 1–32)

**Repeat the entire dance from the beginning**

## Israel  Yibanei Hamigkdash

The translation for this dance is "And the Temple Shall Be Rebuilt." It was presented by Dani Dassa at the 1972 San Diego State College Folk Dance Conference. She learned the dance in Israel during the summer of 1969. It was originally choreographed by Yoav Ashriel.

| | | |
|---|---|---|
| **Pronunciation:** | yib-bah-NEH ah-meek(g)-DAHSH | |
| **Formation:** | Single Circle facing center | |
| **Position:** | Hands held in low V | |
| **Meter:** | 4/4 | |
| **Sequence:** | A. Steps traveling R, and two-steps | |
| | B. Two-step toward center, walks out of circle, yemenite | |
| | C. Walks and two-steps | |
| **Basic Steps:** | Walk, two-step, yemenite | |

# Dance Description

*Meas*

1-4        Introduction (Cts 1-16)

### *Part I*

1          Step to R with R FT (Ct 1), step beside R FT with L FT (Ct &), step with a heavy accent to R with R FT (Ct 2), step on L FT (Ct 3), bounce twice on L heel while swinging R FT across L FT to face RLOD (Ct 4 &)

2          Traveling RLOD step R FT FWD (Ct 5), step L FT beside R FT (Ct &), step FWD again with R FT (Ct 6) repeat and reverse same Ftwk backing up LOD (Cts 7-8) (This is a two-step FWD and a two-step BK)

**Repeat Part I**

### *Part II*

1          Traveling FWD toward center of circle, step FWD with R FT (Ct 1), step beside R FT with L FT (Ct &), step FWD again with R FT (Ct 2). Let go of hands and snap fingers up above shoulders in air *while* stepping with L FT swinging R FT behind L FT facing LOD (Ct 3). Step R FT FWD traveling away from center of circle (Ct 4)

2          Step L FT FWD still traveling away from center of circle (Ct 5), push RT shoulder BK and do a half turn to face center of circle, step BK with R FT (Ct 6), step BK with L FT (Ct 7), step BK with R FT beside L FT (Ct &), step FWD with L FT (Ct 8). (Counts 7 & 8 are known as a yemenite step)

**Repeat Part II**

### *Part III*

1          Traveling LOD holding hands, step R (Ct 1), step L (Ct 2), step R (Ct 3), step L FT beside R FT (Ct &), step R FT FWD (Ct 4)

2          Turn to face R LOD, so that you may travel BKWDS LOD. Step BK with L FT (Ct 5), step BK with R FT (Ct 6), step BK with L FT (Ct 7), step to R side with R FT facing center of circle (Ct &) stepping on L FT XIF of R FT to end facing LOD (Ct 8) (Counts 7 & 8 are also known as a yemenite step)

**Repeat Part III**

**Continue to repeat I, II, III until end of music**

## Lithuania  Ziogelis

"Ziogelis" was introduced in California by Vyts Beliajus who was known as "Mr. Folk Dance" in the United States. It is an occupational dance telling a harvest story. The two-step represents the romancing of the grasshoppers as they go through the rye.

| | |
|---|---|
| **Pronunciation:** | ZEE-gay-lihss |
| **Formation:** | Sets of three, facing each other. M stands between the 2 W. |
| **Position:** | M's arms around waist of W on each side. W put their inside arm on M's shoulder closest to them. Their outside hand holds skirt. |
| **Meter:** | 2/4 |
| **Sequence:** | A. Chorus, elbow swing and change sides |
| | B. Chorus, W slide across |
| | C. Chorus, arches |
| | D. Chorus, trio arch: R hand high, L W under |
| | E. Chorus, circle 3, L and R |
| | F. Chorus, circle 6, L and R |
| **Basic Step:** | Grasshopper: All start with R foot, move FWD with 2 two-steps. Finish second two-step by bending L knee, body in a FWD dip. Starting with R foot, do 2 two-steps BK, ending with body dipping BK. Repeat. |

## Dance Description

*Meas*

1–2   Introduction (Cts 1–4)

**Part I**

1–8   Chorus (grasshopper step) (Cts 1–16)

9–12   W on M's R move into center, hooking R elbows to turn 1-1/2 times and change sides. This takes 4 two-steps. W on M's L and M do two-step balancé in place (step R, ball change, step L, ball change) (Cts 1–8)

13–16   **Repeat Meas 9-12, with W on M's L changing sides** (Cts 1–8)

### Part II

1-8     Chorus (grasshopper step) (Cts 1-16)

9-12    W on M's R face M, slide BK to original position, passing opposite W BK to BK. M and L W two-step balancé (Cts 1-8)

13-16   **Repeat Meas 9-12, with L W sliding to original place** (Cts 1-8)

### Part III

1-8     Chorus (grasshopper step) (Cts 1-16)

9-16    M slide in front of R W with 4 slides, M turn to face each other, two-step balancé FWD and BK 2 times, then slide L BK to place with 4 slides. W join inside hands and change sides, with W in set 1 making arch as W in set 2 dive under arch. W turn in toward Ptr and two-step BK to place with W in set 2 making the arch. Two 2-steps to change places and two 2-steps to turn BK to face center of set in the arch figure. (Cts 1-16)

### Part IV

1-8     Chorus (grasshopper step) (Cts 1-16)

9-12    Do 4 two-steps. M makes arch with R hand high. L W goes under as W cross in front of M. M follows L W under arch and set faces out (Cts 1-8)

13-16   **Repeat Meas 9-12, with L hand high and R W under. M follows R W and set faces center again.** (Cts 1-8)

### Part V

1-8     Chorus (grasshopper step) (Cts 1-8)

9-12    Join hands in low "V" in circles of 3 and move CCW with 4 two-steps (Cts 1-8)

13-16   Reverse circles of 3 and move CCW with 4 two-steps (Cts 1-8)

### Part VI

1-8     Chorus (grasshopper step) (Cts 1-16)

9-16    Join hands in low "V" in circles of 6, moving CW with 4 two-steps. Reverse for 3 two-steps and end by swinging arms FWD and up and calling "HEY." (Cts 1-8)

## Additional Information

This dance can be memorized remembering three basic figures. In the first two figures, the ladies change sides. The next two figures are arch figures. The last two are circle figures.

# Costumes: A Tradition

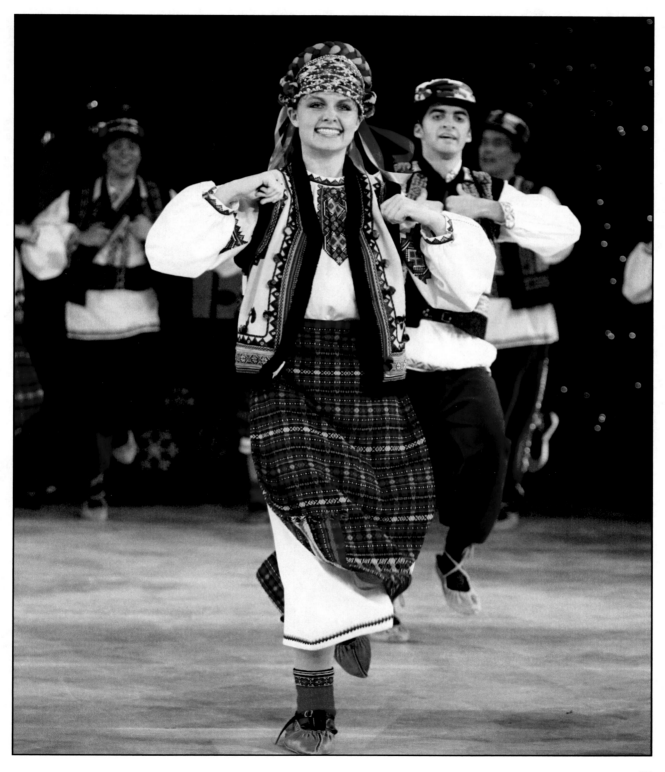

# Costumes: A Tradition

Costumes are a vibrant part of any folk dance and speak volumes about the cultures they represent. One country can have numerous costumes since the costumes vary region to region. A good example of this comes from Switzerland. Her neighbors, such as France, with her pastel shade; Germany, with the halsmentel (yoke); or Austria, with her pleated skirts, have all influenced the costumes of Switzerland. Every country has had its own traditional dress influenced by the people who border them.

A costume develops for valid reasons. It reflects the people's taste, their customs, and traditions. The way in which costumes develop can be fit nicely into three categories.

## 1. Necessity

This includes the following factors:

*Location.* For example, the great variety of Ukrainian costumes are dictated by the geographic conditions in the different regions of the Ukraine. Ukraine occupies a large territory—from the Carpathian Mountains to the Caucases; the dress in each area is unique, adapted to the surroundings, such as the light-weight clothing of the people of the plains (steppes), contrasted with the fleece-lined jackets of the mountaineers.

*Climate.* Weather affects the type of materials used for the construction of costumes. Where there are hot summers and severe winters, lightweight materials are used in the summer, and wool and fur fabrics are used in the winter. Different types of headdress and footwear usually are adjusted to the changing of the seasons.

*Occupation.* The type of clothing worn is dictated by the work being done. Many clothes came about because of people's work. An apron for women or chaps for men were worn in the early time periods of American dress because they were used during a regular day's work. This became part of the costume as time went on.

*History.* The fashion of the day also prescribed the way in which costumes came about. Each era has its own emphasis on what is socially acceptable to the culture. Perhaps there must be a darker color worn for a woman in Romania after she is widowed, while a young unmarried girl must wear lighter colors in the embroidered parts of the costume.

*Gender.* Men and women have always worn costumes that indicate their gender. Many costumes in certain societies are worn to attract a mate and draw attention to their station in life. Polynesian women dancers often wear a grass skirt as they do the hula. This attire helps emphasize the hip action and bring attention to their skill and finesse.

## 2. Symbolism

This includes the following factors:

*Ritual or religion.* Ritual or religion allow for ties to a culture's traditions and value systems. Many of the costume parts have significant meaning that is related to sacred ritual. An example of this can be seen early in the history of the Ukrainian people. They believed that they would be protected from evil spirits because of their colored and intricate embroidered symbols.

*State or country.* The type of designs that are displayed in the costume are often influenced by state or country. In Mexico, many costumes have designs of an eagle or other important animals found in their culture, woven or sewn into their clothes. Colors are also a determining factor; many countries have their flag colors also displayed in the costume. Embroidery, weaving, leather, and metal work affect the way in which a costume gives clues as to its meaning and how it develops.

## 3. Decoration

This includes the following factors:

*Individual Representation.* Rank and status in the society are often displayed through costuming. An American "Cowboy" may wear a very large brass belt buckle because cowboys have won the buckle in a rodeo. Any personal decoration allows the individual his or her own identity.

*Celebration and Splendor.* Celebration and splendor also dictate how a costume develops. To be the most beautifully dressed, as in the court era of France, wigs, elaborate coats, pants, and shoes, and even a gilded cane were used for the great balls. Those with more financial means could afford more decoration, even with precious jewelry.

*Props.* Often, a prop (an object used in a dance), is needed to add to the overall visual affect. China perhaps uses props to the best advantage. Props help tell traditional stories, or they add to the excitement of the movement and sometimes help to indicate the difficulty of the dance piece.

Costumes have many functions. Why are they so important to dance? Because often they dictate the movement that is allowed. If wearing a women's Japanese costume, very small steps are needed because the tight fitting dress comes to the ankle, thus much emphasis is placed on hands and facial expressions. The Israeli women's costume allows for large movement because the dress has a full skirt that is conducive for leaps and jumps.

The type of footwear worn also greatly affects movement and dance style—examples are boots, opanki (flat leather shoes), clog shoes, laced ballet slippers, character shoe, or barefoot. The footwear determines the sounds created by the feet.

A full lifetime could be donated to the study of costumes of the world cultures. This text gives a few examples of costumes from a variety of countries that help the reader to gain an appreciation for the art of costuming and to help identify with the dances from the countries in the text.

# Costume Descriptions of Various Countries

Costumes reflect a traditional dress of a people. Listed are basic descriptions of a common regional costume. The description reflects only one costume out of the many styles found within a country.

## Bulgaria

Bulgarian costumes are so specific in design that it is possible to tell the exact region, village, or even household the clothes represent. One of the most distinctive costumes comes from the Söp region. The women may wear an embroidered blouse with a banded collar and long sleeves cut to a flare at the wrist. The sleeveless jumper is fitted at the waist with a V-style skirt extending to the middle of the lower leg. A white underskirt is worn, embroidered along the bottom. Wool socks are born with a flat, leather, slipper-type shoe. A leather belt is worn loosely at the waist of both the men and women. The dancers use these belts to hold onto each

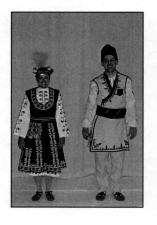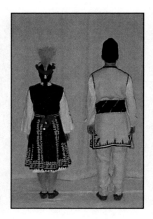

other in lines. Colorfully decorated headgear is always a beautiful addition to the women's costumes. Gold necklaces attached with many coins are worn around the neck.

The men wear a shirt with a banded collar which tucks into full-cut wool pants that taper at the ankle. A sleeveless wool jacket, which overlaps to one side, is embroidered with braid. The jacket is tied together with a wide sash. The footwear is the same as the women's. A sheepskin hat completes the costume.

## Germany

The costume varies depending on the region and reflects the style of neighboring countries. The women's costume usually has a snug bodice over a full-sleeve blouse with a ruffle around the neck. The skirt, fitted at the waist, is often gathered to add extra fullness. A long apron covers the skirt and ties in the back. Petticoats add fullness. Most German costumes are not embroidered. The name for the costume is "Derndl." Footwear is generally a black, leather character-style shoe. Women also wear hats of various styles.

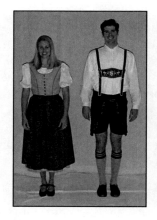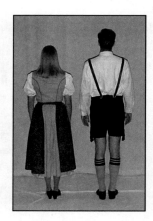

The men often wear "lederhosen," which are leather shorts with suspenders. The slapping of the men's hands on the leather shorts adds increased sound to the various rhythms of the dance. The costume includes a white, long-sleeve shirt that has a stand-up collar with a red bow knotted at the neck.

A hat is worn and usually has a plume for decoration. Black buckled shoes add to the decoration of the feet. Men wear socks to the knee, held up by red garter ribbons.

## Hungary

The Hungarian costumes are among the most decorative and elaborate in Europe. The women's costume from Gederlak uses beautifully detailed embroidery, very full skirts, and layers of petticoats. Their snug hat, vest, blouse, and apron are all decorated with "open-work stitching." Even the color of the embroidery symbolizes the age of the girl or woman and her status in life. The skirts are finely pleated cotton or linen in a plain or floral design. An open-back slipper with a small heel is usually worn. Many rows of red beads are worn around the neck.

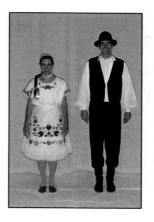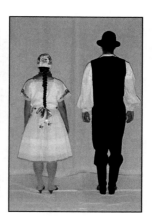

The men's costume feels masculine, with dark hat, vest, and pants. The tight black pants, known as "hussar trousers," tuck into black boots and are worn with long-sleeved shirts with a gathered cuff and an open collar. The vest is waist length, trimmed with plain gold buttons. The men's hat is made of black felt.

## Israel

The Israeli heritage is both old and new. The "old style" is the Yemenite costume patterned after the Jews who came from Yemen to Israel. But the "Hora" costume is the costume most common to Israel.

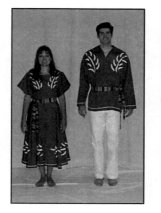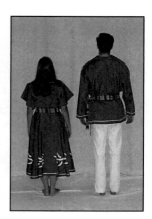

The women wear a long full-skirted dress with loose wide sleeves. It usually has a zippered back and is fitted at the waist. A belt may be worn around the waist. The skirt's full cut allows for large movement.

The men wear a loose shirt outside their pants and may wear a sash around their waist. The pants are a loose straight design, which allows for large leaping and jumping movements. Neither the men nor women wear headdress. The design on the costume in the text has sheaves of wheat, symbolizing the belief of ongoing life and the concept of eternity.

Both the men and the women dance barefoot, to be able to touch the soil with their feet to show respect and love for their country.

## Lithuania

Lithuanian costume material is all hand-loomed. The floral and geometric designs are woven directly into the fabric. The women wear a white blouse with full sleeves gathered into cuffs. A long skirt with horizontal bands and stripes is partly covered by a striped sleeveless jacket that extends to the hip. A long woven apron is also worn in the same type of fabric. A circular crown-type headpiece has the same design as the skirt and also has a woven bow hanging down from the back of the headpiece. White stockings and flat leather shoes complete the outfit.

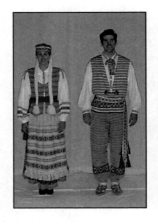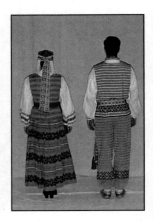

The men also wear a white-collared shirt with full sleeves gathered into cuffs at the wrist. A bow is tied at the neck, and their pants are very wide at the ankle. The same woven geometric pattern in the women's costume is found in the men's material. A sleeveless vest is worn, a sash tied at the waist. Flat leather slippers are also worn.

## Mexico

Mexico is a "kaleidoscope of color" when it comes to costuming and it has a variety of costumes, depending on the region and purpose for which they are worn. Mexican history has a profound effect on the cultural diversity and thus the costume.

A typical costume of the women is a skirt made of light-weight cotton that extends below the knee. It should be constructed out of a double circle of material to give extra fullness to the skirt. An underslip is worn, with a scalloped edge of white lace. The blouse is tucked in at the waist and has a

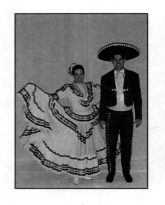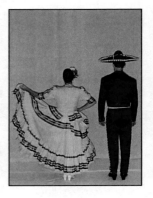

full-sleeve gathered to the elbow. Ribbon decorates the blouse and skirt in bright contrasting colors.

A "rebozo" (a long and narrow, tightly woven fabric) is hooked around both arms and allowed to hang in the back. It should be of a different color than the costume. Bright colored flowers are worn in the hair. Heavy bracelets, necklaces, and big earrings add decoration. The tight-fitted boot laces up the front to about mid calf.

The mens' national attire is the "Charro," or horseman's costume from the state of Jalisco. It has a short jacket and tight-fitting pants. Silver buttons (or the soutacke design work) decorate the outside leg of the pant. The shirt is of white linen or cotton and has a long silk bow of a bright color tied around the neck. A large sombrero with decorative silver threads may be worn. Ankle boots, with a strong heel, accompany the outfit. The bottom of the boots usually has small nails pounded into the sole to provide a louder sound for the intricate foot rhythms.

## Philippines

Because of the numerous islands, there is much diversity in the style of costumes worn. One of the most recognized and attractive costumes worn by the women is known as the "Maria Clara." The butterfly shoulder design emphasizes the movements made by the arms of the women as they move up and down. It is often made of taffeta, silk, or fine cotton in a pattern with a broad stripe. A ruffle at the bottom of the skirt allows for more movement. A triangle scarf is tied at the waist with a sash draped over the shoulder. Flowers are worn in the hair.

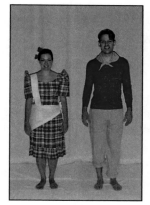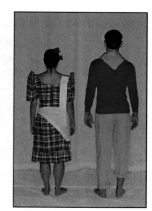

The men have a long-sleeve, collarless shirt of a solid color. A triangle scarf is tied at the neck. The pants have one leg rolled up in a cuff, but the other one is long. Both men and women are barefoot.

## Russia

Vibrant and colorful Russian costumes are made from Russia's own woven materials. The women wear a white three-quarter-length gathered sleeve blouse with a ruffle around the collar. A sleeveless dress is fitted at the waist with the skirt cut in a flare for fullness. There are many decorative patterns on the dress and sleeves of the blouse. Large bows are worn in the hair. Usually a red, low-heel character shoe may be worn on the feet.

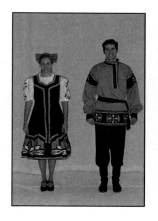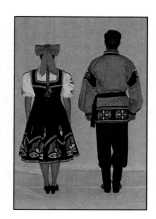

The men wear a loose-fitting shirt that overlaps the pants, with a wide band tied at the waist. The men's shirt also has decorative trims on it that usually coordinate with the women's costumes. Black pants are tucked into knee high boots. A wool fleece hat is sometimes worn for the men.

## Scandinavia

The costumes are usually a solid color, either blue, red, green, yellow, or black. These colors reflect the colors found in the countryside and also blend with the colors of the seasons. The women wear long, full skirts with a colorful apron on top. Tied around the waist is an "aumoniere" (a flat bag used as a pocket), either square or oval in shape and embroidered with bright colors. They wear a sleeveless vest that is laced up at the front and worn over a long-sleeved white blouse. On the head a cap or bonnet is worn. Sometimes a shawl is also worn to complete the outfit.

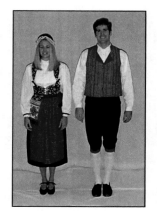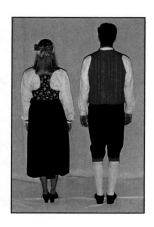

The men's costume includes a white shirt with a sleeveless waistcoat, usually in red (with or without a stripe pattern), fastened down the front with metal buttons. They have dark breeches fastened below the knee with red braid and sometimes pom-poms. White socks and black shoes are the standard. Some regions will wear a woolen top hat.

### Ukraine—Hopak Costume

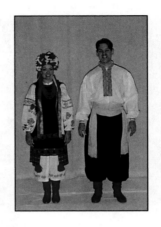 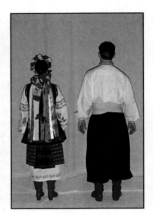

Ukrainian costumes have many layers and are very symbolic. The women wear a long-sleeve dress that extends to mid calf. It can be made out of a white, lightweight, cotton-blend material with embroidery on the sleeves and cuffs, along the bottom of the skirt, and around the neck, extending in a rectangle down the front. The embroidery is always red and black and is cross-stitched. A knee-length "platkha" wraps around the back and ties in the front at the waist. It is usually in the design of one-inch squares with a red-wood pom-pom on the two bottom corners of the platkha. The next layer is a velvet apron with trim along the bottom. It is placed in the front on top of the platkha, tying in the back. A sleeveless jacket, made of the same material as the apron, is the next layer. It overlaps and fastens in the front. In the back, there are fitted pleats at the waist. A beautiful floral head piece with long ribbons hanging down the back adds to the kaleidoscope of color. Red boots with a low heel are worn. To complete the costume, many rows of coral-colored beads are worn at the neck symbolically to ward off evil spirits.

The men's costume is much simpler—a white, long-sleeved shirt with a banded collar. Embroidery is found along the neck, down the front in a rectangle, and around the cuffs. The shirt tucks into very baggy pants. The pants are tucked into red leather boots. A sash is tied around the waist, the two ends hanging down either side of the body.

### United States of America—Western Square Dance

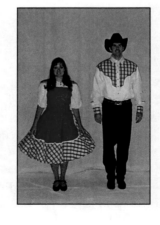 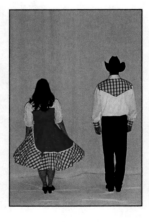

Costuming in the United States of America is much simpler than costumes from most countries. The women have a one-piece dress that flairs from the waist and reaches just below the knee. It has puff sleeves to the middle of the upper arm. The dress is usually made from a cotton-blend material. This allows the dress to be lightweight, which creates greater ease in movement for the dancers. A full, gathered slip is worn under the dress to promote fullness. Plain black shoes are worn on the feet.

The men wear a "cowboy" hat with a turned up rim. The shirt is long-sleeved with a standardized collar. It may either have snaps or buttons up the front. A narrow strip of material known as a "trail tie" is worn around the neck, tied in a square knot. The trail tie has replaced the traditional handkerchief. "Cowboy" boots are worn on the feet. Straight-cut pants and a leather belt with a big belt buckle complete the costume.

# Bibliography

Casey, Betty. *International Folk Dancing U.S.A.* Doubleday & Company, Inc., Garden City, New York, 1981.

Duggan, Anne Schley, Abbie Rutledge, and Jeanette Schlottmann. *Folk Dances of the United States and Mexico.* New York, New York, A. S. Barnes and Company, 1948.

Dunin, Elsie Ivacic. *Dances in Macedonia.* Skopje, Macedonia, Tanec Ensemble, 1995.

Eden, Ya'akov. *Moving in International Circles.* Kendall/Hunt, Dubuque, Iowa, 1988.

Gilbert, Cecile. *International Folk Dance at a Glance.* 2nd Ed. Minneapolis, Minnesota, Burgess Publishing Company, 1974.

Harris, Jane A., Anne M. Pittman, and Marlys S. Waller. *Dance a While.* 7th Ed., New York, Macmillian College Publishing Company, 1994.

Harrold, Robert. *Folk Costumes of the World.* Dorset, Illinois, Blandford Press, 1981.

Halasz, Zoltan. *Cultural Life in Hungary.* Budapest, Hungary, Pannonia Press, 1966.

Housten, Ron. *Folk Dance Problem Solver.* Texas, X-Press, 1984–1990.

Jensen, Clayne R., Mary Bee Jensen. *Folk Dancing.* Provo, Utah, Brigham Young University Press, 1978.

Joukowsky, Anatol M. *The Teaching of Ethnic Dance.* New York, New York, J. Lowell Pratt and Company Publishers, 1965.

Kraus, Richard G. *Folk Dancing.* New York, The Macmillan Company, 1962.

# Study Guide Section

# Study Guide
# (Country, Formation, Position)

Every country has its folk dances that have developed historically over time. They are each unique to their own area within the country itself. Many of the formations and positions tell much about a dance, and therefore, the people. Answer the following:

**FILL IN THE BLANK**

| Dance | Country | Beginning Formation | Beginning Position |
|---|---|---|---|
| Armenian Miserlou | | | |
| Arnold's Circle | | | |
| Bučimiš | | | |
| Canadian Barn Dance | | | |
| Corrido | | | |
| Čapkan Dimčo | | | |
| Cotton-Eyed Joe | | | |
| Cumberland Square | | | |
| Czardas Vengerka | | | |
| Da Mi Dojdeš | | | |
| Debka Shachar | | | |
| D'Hammerschmiedsg'selln | | | |
| Doudlebska Polka | | | |
| Hora de Mîna | | | |
| Jacob Hall's Jig | | | |
| Jovano Jovanke | | | |
| Kolubarski Vez | | | |
| Komletrø | | | |
| Korobushka | | | |

| Dance | Country | Beginning Formation | Beginning Position |
|-------|---------|---------------------|--------------------|
| Kosa | _____ | _____ | _____ |
| La Bastringue | _____ | _____ | _____ |
| La Raspa | _____ | _____ | _____ |
| Metelytsia | _____ | _____ | _____ |
| Mona's Festvals | _____ | _____ | _____ |
| Orijent | _____ | _____ | _____ |
| Oslo Waltz | _____ | _____ | _____ |
| Road to the Isles | _____ | _____ | _____ |
| Rustemul | _____ | _____ | _____ |
| Salty Dog Rag | _____ | _____ | _____ |
| Sauerlaender Quadrille | _____ | _____ | _____ |
| Somogyi Karikázó | _____ | _____ | _____ |
| Stav Lavan | _____ | _____ | _____ |
| Sweets of May | _____ | _____ | _____ |
| Syrtos | _____ | _____ | _____ |
| Tokyo Dontaku | _____ | _____ | _____ |
| Trip to Bavaria | _____ | _____ | _____ |
| Uvneh Yerushalayim | _____ | _____ | _____ |
| Yibanei Hamigkdash | _____ | _____ | _____ |
| Ziogelis | _____ | _____ | _____ |

# Study Guide
# (Costuming)

Costuming is extremely important to the cultures these costumes represent. It often dictates the type of movement in a dance. Following are some typical test questions that apply to costuming.

A.  Many costumes developed out of *necessity*. Name some factors that affect how costumes came about. Give three examples that are specific to a selected country.

1.

2.

3.

B.  Many costumes developed because of *symbolism*. Discuss the factors that influence the symbolism found in costumes. Give three examples that are specific to a selected country.

1.

2.

3.

C.  *Decoration* is an important part of costuming. Give some factors that affect decoration used in costuming. Give three examples from specific countries.

1.

2.

3.

D.  How does *footwear* affect how a dance is performed? Name three different kinds of footwear from different countries and explain how they affect the dance.

1.

2.

3.

E.   Discuss how a *prop* affects how a dance is performed and give an example.

F.   Discuss symbolism as it relates to the Mexican men's and women's costumes.

# Study Guide
# (Sample Test)

**PART I**    Indicate which statements are True or False by circling the correct letter.

1) T    F    A čukče is the same as a hop.

2) T    F    CCW and RLOD refer to the same direction of dance.

3) T    F    Israeli dancers dance with bare feet because of the difficulty of the dance steps.

4) T    F    Improvisation does not fit into the structure of folk dance.

5) T    F    In a "V" position, hands are held high above the head.

6) T    F    Folk dancing is a celebration of what people used to do in villages.

7) T    F    A handkerchief should separate the men and women in Jovano Jovanke.

8) T    F    The leader in a line dance is located on the right side of the line.

9) T    F    The Yemenite step is common to Yugoslavian dancing.

**PART II**    Answer the following questions in a concise manner.

1. What does the abbreviation RLOD stand for?

2. What is the translation of D'Hammerschmeidsg'selln?

3. The bihunets step is used in which dance?

4. Name two more steps used in the dance in question 3.

5. Define "styling" as it is used in folk dance.

6. Give three dances that use a polka step.

**PART III**    Identify the correct footwork for each of the following steps by choosing from the column on the right.

| | | | |
|---|---|---|---|
| 1. | Polka | A. | Step R fwd; bring L to R; step R fwd, hop R; swing L ft slightly fwd. Basic step pattern: Step, step, step, hop. |
| 2. | Two–step | B. | Hop L (ct &), step R (ct 2), step L ft beside R ft (ct &) step R (ct 4). Basic step pattern: Hop, step, close, step. |
| 3. | Schottische | C. | Step R ft fwd, bring L ft to R, step R ft fwd and hold. Basic step pattern: Step, close, step (pause). |

**PART IV  Fill in the blank with the most correct response.**

1.  In the Canadian Barn Dance, you move _____ (direction) to get a new partner.

2.  Stav Lavan uses _____ (time signature) rhythm.

3.  Road to the Isles uses a _____ position throughout the dance.

4.  In the dance Korobushka, the men do a _____ Bokazo first, and the women do a _____ Bokazo (foot).

5.  Name the dance that is often done at weddings: _____

**PART V  List the correct sequence for the following dance by using the steps at the right and placing the letter of the step in the blank provided on the left.**

A.  Cotton-Eyed Joe

_____ 1.                        A. Push step
                                   B. Partners polka turn
_____ 2.                        C. Heel-toe Polka
                                   D. Individual turn and stomps
_____ 3.

# Study Guide
## (Maps)

Following is a map that is blank. Fill in the names of the countries, seas, and oceans using the labeled map in the text as an example.

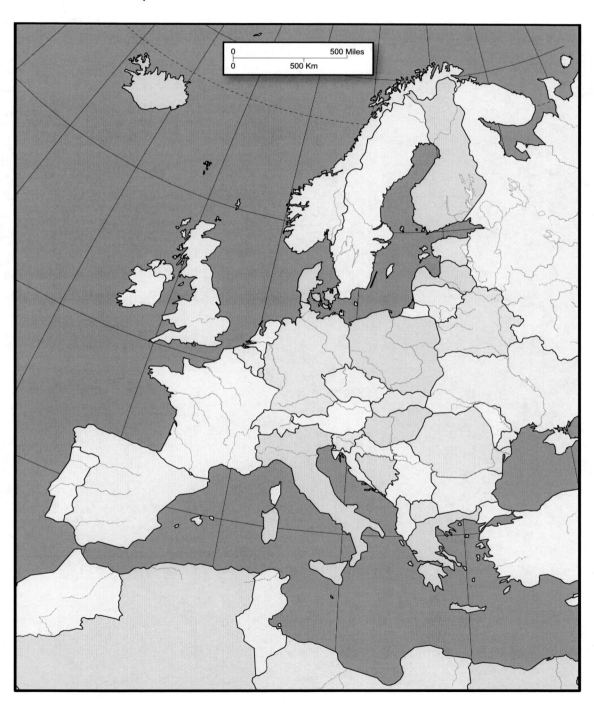